HAUNTED
SHELBY COUNTY,
ALABAMA

HAUNTED
SHELBY COUNTY, ALABAMA

KIM JOHNSTON

HAUNTED
AMERICA

Published by Haunted America
A Division of The History Press
Charleston, SC 29403
www.historypress.net

First published 2013

Manufactured in the United States

ISBN 978.1.60949.927.3

Library of Congress Cataloging-in-Publication Data

Johnston, Kim.
Haunted Shelby County, Alabama / Kim Johnston.
pages cm
Summary: "Discover the ghosts in and around Shelby County, Alabama"-- Provided by
publisher.
Includes bibliographical references.
ISBN 978-1-60949-927-3 (paperback)
1. Ghosts--Alabama--Shelby County--Anecdotes. 2. Haunted places--Alabama--Shelby
County--Anecdotes. 3. Historic buildings--Alabama--Shelby County--Anecdotes. 4.
Historic sites--Alabama--Shelby County--Anecdotes. 5. Shelby County (Ala.)--Social life
and customs--Anecdotes. 6. Shelby County (Ala.)--History, Local--Anecdotes. I. Title.
BF1472.U6J6555 2013
133.109761'79--dc23
2013032984

This book is dedicated to my three children, Lucas, River and Chance. May you always be blessed with love and a childlike wonderment for the mysteries of this world.

CONTENTS

Acknowledgements 9
Introduction 11

PART I. MONTEVALLO
The Cunningham Stamps House 13
Aldrich Mining Ghost Town 18
The Dry Valley Path Spirit 26
Legends of Brierfield 27

PART II. CALERA
The Old May Plantation 31
The Shelby Springs Manor 37

PART III. HARPERSVILLE
Ghosts of the Creek Trail of Tears 47
Ghosts of the Chancellor Place 57
The Klein Wallace Home 64
Old Baker Farm 67
The Black Cat Bone 70

CONTENTS

PART IV. SHELBY
Shelby Hotel 73
Old Shelby Cemetery 76

PART V. CHELSEA
The Devil's Corridor 79
The Yellow Leaf Creek Trail 81
Chelsea's Urban Legends 85

PART VI. LEEDS
The Ghost of John Henry 87
Sicard Hollow Road 92
The Dunnavant Valley Mystery 93
Elvis at the Visitor Center 95

PART VII. STERRETT
Field of Apparitions 99

PART VIII. WILSONVILLE
The Densler House 101

PART IX. HELENA
Mischief at Magnolia Springs Manor 107

PART X. ALABASTER
The Buck Creek Mill Phantom 113

Bibliography 121
About the Author 125

ACKNOWLEDGEMENTS

First, I would like to thank my family for being understanding of the numerous late nights it took to accomplish this project. My husband, Dan, had the daunting task of pacifying our three rambunctious children without my help at times, and he deserves a pat on the back. Thank you, Dan, for being like the peanut butter of the family—holding us all together. My children, Lucas, River and Chance, had to put up with early bedtimes more often than not, but they did not protest too many times, and for that, I am truly grateful. Thanks to all three of you. Mom loves you all so much. Thank you to my parents, Ken and Charlene Currie, as well, for they were the first people to open my mind to the world of the unexplainable. My father is the best storyteller I know and a great source of inspiration for me.

To my second family, the paranormal researchers, your support and friendship throughout have been invaluable. My team mates on the S.C.A.R.E. Alabama team—Shane Busby, Nicole Sparks and Blaine Rohan—have played an instrumental part in this book. You each had faith in me as well when this team was just getting started. Your loyalty and encouragement could always be counted

on. Members of other teams have played an important part as well, such as Kevin White from Parabama Investigations, Tracy Jones from Triple J Ghost Hunters and Faith Serafin from the Alabama Paranormal Research Team. You all have been amazing to work with, and I feel honored to call you my friends.

There have been so many other people along the way who have shared their stories and touched my heart—Mike Leonard, Theo Perkins, Carolyn Dorris, Diane Moore and each of the seniors I spoke to at the Alabaster Senior Center, to name just a few. Of course, my job would have been much more difficult, if not impossible, without the great work of Bobby Joe Seales and the Shelby County Historical Society. I give enormous thanks to you all for helping make this book possible.

INTRODUCTION

It has been said that Andrews Jackson's men were so impressed with the beauty of Shelby County after the War of 1812 that they returned with their families to settle here and start a new life. I, too, have often wondered why anyone would want to live anywhere else after returning from long road trips and being greeted by a picturesque sunset as I hit the top of Double Oak Mountain just before home. This beautiful county was named in honor of the first governor of Kentucky, Isaac Shelby, who was a Revolutionary hero. Three sites within its borders claim to be the geographical center of Alabama—the true heart of the state.

Underneath the physical beauty, bustling communities and thriving businesses that are now a part of present-day Shelby County, I have learned there lies an ugly past. The Creek Wars, Trail of Tears and Civil War all left marks on this land. Although the Creek War battles were not fought on the soil here, the Indians who lived here lost their homes as a direct result. More times than not, acts of brutality were used to remove them. The Civil War brought its own set of challenges to Shelby such as starvation and marauding bands of deserters terrorizing communities. Wilson's Raiders, a special division of the

Union army, destroyed factories, furnaces, arsenals and towns across the county. More than nine hundred sick and wounded Confederate soldiers were sent to Shelby Springs by train during the Civil War. Something that significant in history, causing so much destruction and suffering, is bound to leave a scar. Some of the wounds have never healed, and that is perhaps why the stories and sightings of ghosts in the area abound.

Not all of the stories within these pages are born from tragedy. Sometimes the bonds of friendship and the sense of loyalty can extend into the afterlife. You will read the personal family stories of some of the old plantations that still grace Shelby County today from Montevallo to Harpersville. You will read about the hardworking people who lived and worked at Buck Creek Mills. There are stories within that have touched my heart and those that have sent a chill down my spine. From sightings of the Virgin Mary to the King of Rock-and-Roll himself, *Haunted Shelby County, Alabama* has a little something for everyone.

For a detailed account of all the ghosts of the University of Montevallo, please check out *Haunted Birmingham*, written by Alan Brown and published by The History Press.

MONTEVALLO

THE CUNNINGHAM STAMPS HOUSE

Off Highway 119 near Montevallo and down a long, tree-lined driveway is the majestic home of Sherwood and Beverly Stamps. Surrounded by flowering meadows, the grand 1820s home sits on a knoll that overlooks bountiful green pastures and livestock. Taking in the view and the surroundings, it is no wonder that the home and eight hundred acres that accompanied it was chosen by young newlyweds Joseph and Elizabeth Cunningham. It was an ideal place to cultivate the land and raise a family. The fertile soil would provide ample crops and supply the family with enough money to enjoy the finer things in life. However, not too many people know the stories of sadness that once took place here long ago.

The Cunninghams enjoyed several happy years on this plantation at the beginning. According to Roy Cunningham, a descendant and longtime resident of Montevallo, Joseph was very hardworking. His dedication and good investments paid off. Joseph's success in planting allowed Elizabeth to enjoy decorating

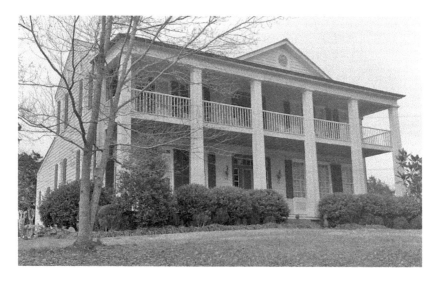

The Cunningham Stamps House as it stands today. *Author's collection.*

the home with fine silks and expensive furniture. At dinner parties, they served only the finest imported wines. Joseph adored his sweet wife and their growing family. They had four lively girls and one little boy who filled their home with the sounds of giggles and children at play. Much too soon, though, their house would be filled with unbearable grief.

In 1831, Elizabeth gave birth to a second son. Joseph was a proud father and delighted to have another boy, but not long after the birth, his joyous feelings turned to concern. It became evident that the newborn was very weak and would not survive. Joseph felt helpless. He had always succeeded in everything he put his heart into. Yet, at this moment, there was nothing he could do, and the tiny life quietly slipped away in his mother's arms. The parents were overwhelmed with grief at the loss of their son. Joseph made arrangements for the child to be embalmed, and the plantation's carpenter, a slave they called Uncle Mink, lovingly built a little oak coffin. When the child's body was returned to Joseph, he was asked about the funeral arrangements. Perhaps still in shock, Joseph growled in reply, "There

won't be any funeral," and put the child in a closet under the stairs. Elizabeth, weakened by her sadness, had not been able to get out of bed since the birth but overheard what was going on. She was disturbed greatly by the thought of her baby not having a proper burial. Four days passed, and she pleaded mightily with Joseph each day to allow her to bury their son. Finally, after Reverend Dr. West, the local Methodist preacher and the town doctor, paid Joseph a visit, he relented. The child was buried in Salem Cemetery in Montevallo the next day.

The following year, another child was born to the young couple, a strong, healthy baby girl. It seemed, though, that Elizabeth never fully recovered from the broken heart caused by her loss, and having another child so soon only burdened her body even more. Tragically, Elizabeth died in the summer of 1833, leaving behind a doting husband and six children. She was laid to rest next to her baby boy in Salem Cemetery. Joseph commissioned a brick mausoleum with an iron door to be built over their graves. The mausoleum no longer stands today, as it was destroyed during desperate times in the Civil War by Union soldiers looking for treasure. Sadly, the baby's grave was also desecrated in the hopes that a tiny gold ring might be found around his finger.

A mother's love knows no bounds, so it is not surprising that shortly after the disturbance of the child's grave, strange happenings began in Salem Cemetery. People passing by on the road at night have reported a glowing light coming from the mother's grave. A woman's shadowy figure has also been seen walking about as if she is looking for something. Elizabeth has made her presence known, and it is quite clear she is watching over her baby boy. After all that she went through to give him a proper burial, she is making sure that his eternal resting place does not get disturbed anymore.

Salem Cemetery is not the only place where Elizabeth has been seen. The current owner of the Cunningham Stamps House, Beverly Stamps, has seen her as well. One night, not long after she had wed Sherwood and moved into the old home,

The Cunningham family graves in Salem Cemetery. Elizabeth is said to haunt the grounds. *Author's collection.*

Beverly was alone in the bedroom trying to fall asleep. She felt as though someone was watching her, so she rolled over in bed and was frightened by a woman with her hair pulled up into a bun wearing an old-timey dress hovering next to her. She could not see the woman's face but could tell that she was wearing a style of dress from long ago. After that, the woman did not bother Beverly. Perhaps Elizabeth was just curious about the new lady of the house. Also, previous owners who were descendants of the Cunninghams had numerous experiences as well. Most notably, the wife was awakened at night on several occasions by the sound of a baby crying for its mother. Each time she would get up to investigate; the crying always seemed to be coming from the downstairs closet. Years later, Mrs. Stamps, who was unaware of the history or the ghost stories of the home, also experienced the phantom baby cries in the middle of the night. She, too, got up to check on her children upon hearing the cries, but all of her children were fast asleep in their beds. The most recent

paranormal activity in the home, though, could be attributed to a third spirit that has not been mentioned yet.

When Beverly's daughter Amy was dating her now husband, Dave Horrie, he had a terrifying experience in one particular bedroom of the home that is just off the living room. This bedroom has been rumored to be the place where James Cunningham, a descendant of Joseph Cunningham, ended his life in 1924. Dave was already nervous to stay overnight because Amy had told him several stories of growing up in the haunted house. He wore his headphones and listened to music to tune out all the creaks and groans of the house settling. He also kept the family's pet Chihuahua by his side that would certainly sound the alarm if anything happened. Dave managed to fall asleep without incident but was startled awake around 3:00 a.m. by a loud crash inside his room. He immediately threw the covers over his head because he had no desire to see what may have caused such a calamity. The dog was strangely quiet, despite his reputation for sounding the alarm at even the slightest of reasons.

As the two hid under the covers, they heard loud footsteps coming down the stairs and toward the bedroom. Dave was relieved to hear the familiar voice of Mr. Stamps, and it was only then that he removed the covers from his head. They discovered that a piece of furniture had fallen over and a telephone on top of it had hit the floor as well. How or why this happened could not be explained. The fallen furniture appeared to have the legs pulled right out from underneath it, and it was lying on its side. It came to a rest partially beneath the bed that Dave was sleeping in. The only explanation that seemed to make sense was that the furniture was pushed over with a good deal of power. We will never know for sure, but Amy and Dave believe the spirit of James Cunningham, perhaps playing a prank on the nervous young man, was responsible for the incident.

For the past several years, the home has been quiet. Perhaps the ghostly residents of the home have finally grown accustomed to the Stamps family, or perhaps the reverse is true and their antics now go unnoticed.

ALDRICH MINING GHOST TOWN

Farrington Memorial Hall is just one building that still remains inside the old Aldrich mining community. The mining village got its start in the mid-1800s with men working by hand with pickaxes and mules hauling the payloads. The coal from the mines would supply Shelby Iron Works during the Civil War in order to make cannonballs and later train wheels, among other things. In 1882, William Aldrich, a three-time U.S. congressman, became principal stockholder in the mines and began building up the town along with his wife, Josephine. Together the pair would create an idyllic community based on Edward Bellamy's novel *Looking Backward: 2000–1887*. With their progressive ideals, they would strive to meet the needs of every miner, black and white, while constructing a palace and gardens for themselves to rival the likes of the Biltmore Estates. According to a short biography of Josephine included in the 1893 book *Woman of the Century*, a compilation of biographies of many leading American women of the time, "The town of Aldrich is a quiet, peaceful, moral and refined community, where the rights of all are respected, and where drink and tobacco are almost unknown." They built schools and a large company store and started civic organizations. These would be the glory days of Aldrich, but despite the utopian way of life, they would not be able to escape heartbreak in the small mining town.

Mrs. Josephine Aldrich was quite an interesting woman. Her mother died when she young, and she was raised in Connecticut by both her grandmothers, who were strict in their biblical conviction of spare the rod, spoil the child. She married twice before she met William. Her first husband abandoned her with three children. Her second husband had been a counterfeiter in New York, so she demanded a divorce from him. Her severe treatment as a child left her heart longing for a different way when she left home. She took an interest in Theosophy and lived by the Golden Rule. She believed in reincarnation and was known to meditate on a regular basis. I

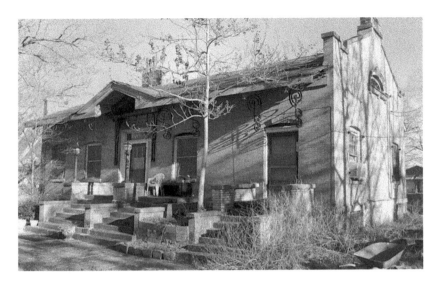

Farrington Memorial Hall as it stands today at the Aldrich coal mining town. *Author's collection.*

imagine she was accustomed to raising a few eyebrows on occasion by the time she married William Aldrich and moved to the small town in Alabama. It must have been her heart of gold that won people over, though, as she and William were both highly regarded in social circles. She even served as secretary of the Theosophical Society of the United States at one point in her life and wrote for a publication called *The Occult World*, which was devoted to reform such as women's suffrage and the political movement known as nationalism. She and William were also known to visit prisons and had an interest in reforming that system as well.

For a period of fourteen years at Aldrich, the couple's dreams came to fruition when they decided to try a convict-lease program in their mines. In 1914, they built a prison encampment complete with a hospital, farm and dairy onsite at Aldrich. The community enjoyed concerts on Sundays performed by the prisoners. The prisoners worked side by side with their free counterparts until 1928, when the state banned the practice of convict-lease. The

halt came after the death of a prisoner at a different company prompted an investigation when he was intentionally lowered into a vat of boiling water as punishment. His death was the last in a long history of abuse and mistreatment of convicts inside mines around Birmingham since the late 1800s. The Aldriches intended to change those practices and undoubtedly left their mark in some small way on the lives of the imprisoned men who worked for them. The prison was dismantled in the same year that the convict-lease program was abandoned. The only thing that remains is a single tombstone on Prison Hill and some unmarked, sunken graves that now have trees growing on them—which is more than remains across the road of the palace that once was Rajah Lodge.

Rajah Lodge was the palatial thirty-room residence in the mining town that William Aldrich built for his wife, Josephine; adopted son, Farrington; and adopted great-granddaughter, Josephine Pratt Aldrich. Designed by a German architect they met in Washington, D.C., it was surrounded by exquisite gardens and fishponds and had six greenhouses dedicated to growing exotic plants. A gardener lived onsite to maintain it all. The Aldrich name was spelled out on a bank alongside the driveway to the carriage house. Rajah Lodge got its unusual name after an artist dreamed of Mr. Aldrich being a rajah of India with Mrs. Aldrich as his maharani. They filled their home with collections from their world travels. Fine art, silver, china and oriental carpets adorned the inside of the home. The outside had multiple balconies overlooking the gardens and town. Mrs. Aldrich liked to do her meditating on these balconies at times, and it was there, as the story goes, that she saw a man beating a mule one morning. She rushed down from her perch and grabbed the whip from the man. She started whipping him and said, "That mule might be my grandmother!" Mrs. Aldrich was not afraid to have a strong opinion and assert herself, but her opinion would be disregarded by her son, Farrington, on one fateful day in 1908.

Farrington Aldrich was adopted in Racine, Wisconsin, by the Aldriches when he was just a baby. He lived a happy life, traveling

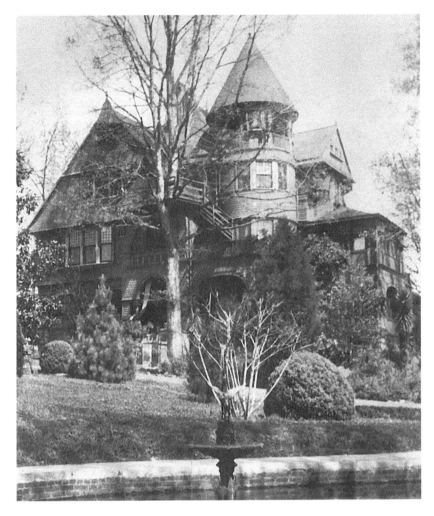

The Rajah Lodge that once stood next door to Farrington Hall. *Courtesy of the Shelby County Historical Society, Inc.*

with his parents and playing with his adopted sister in the little village that his parents had built. His sister had the fondest memories of their time together in the mining village riding in carts pulled by ponies and living at Rajah Lodge. Farrington had a big heart and a good work ethic. He was a cadet at Marion Military

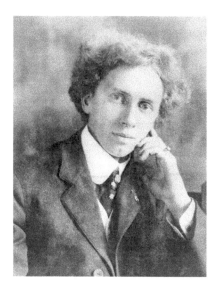

Farrington Aldrich. *Courtesy of the Aldrich Coal Mine Museum.*

School, helped his father with the mines and enjoyed tinkering with cars when his teenage years approached. His father decided to build a place for Farrington to use as a garage so he could pursue his passion for cars. It would also serve as an office for himself and have a recreation room. It would be just as lavish as his residence, only on a smaller scale. The structure sits in the side yard of the now vanished Rajah Lodge. Inside, impressive Spanish leather lines the walls of the recreation room where original hand-painted murals of sweeping landscapes can still be found today. Mr. Emfinger, curator of the Aldrich Coal Mining Museum, says that the murals were painted by Giuseppe Moretti, the same artist who created Birmingham's iconic Vulcan statue. Sadly, Farrington would not live to see this masterpiece completed.

In the summer of 1908, at the age of nineteen, the dedicated and hardworking Farrington decided that a coal mine reservoir near the house needed to be cleaned out. His mother had forbid him from going because she knew it would be mosquito-infested. Farrington disregarded his mother's wishes and cleaned the pool anyway. Not long after, he was burning up with fever. The doctor was called. Mrs. Aldrich begged for the doctor to place her son in a bath of ice to save him, but nothing could be done. Farrington had caught typhoid fever from the mosquitoes at the reservoir, and there was no cure. He passed away on July 7. Everyone was heartbroken, especially little sister Josephine. When the garage and recreation hall was completed, Mr. Aldrich had it named Farrington Memorial Hall in his honor.

Visitors today can get a glimpse into a day in the life at the mining village, as well as what it was like to be a member of the Aldrich family. While Rajah Lodge no longer stands, you can get a sense of the lavishness that must have existed by observing the decoration of Farrington Hall. You might also get a little more than you bargained for, like I did. My experience at this place still keeps me up some nights, despite being an experienced paranormal investigator.

Actually, I am not the first person who has left Farrington Hall a little rattled. Mr. Emfinger's pastor's wife came by for a social function once and experienced the bathroom door flinging open by itself. She was so startled that she left and has never returned. For years before Rajah Lodge was torn down, it sat in disrepair, and many said it was haunted. Mr. Emfinger, who has lived in Aldrich all his life, never believed those stories but does believe Farrington Hall is haunted. In addition to the doors opening on their own, the old Victrola that sits in the back office started up on its own one afternoon while he was in the room working. He also tells the story of how his wife once smelled lilac in the recreation room when she was setting up for a birthday party. She thought it was odd because there were not any lilac bushes around anywhere. She laughed it off and said maybe it was Mrs. Aldrich. A week later, her daughter smelled it too. Several months passed, and Mrs. Aldrich's descendants came to visit the museum. Mr. Emfinger's wife asked them if they knew anything about the lilac smell in Farrington Hall. They confirmed that lilac was Mrs. Aldrich's favorite flower. In fact, they did not grow well in Alabama, so she had a greenhouse dedicated to only growing lilacs at one time. Another visitor to the museum told Mr. Emfinger that she also had grown up in Aldrich and was present during the time that Farrington passed away. She claims to have been inside Farrington Hall the day that Farrington was cremated, which supposedly took place in the building's basement. While Mr. Emfinger is skeptical a cremation would have been possible in the basement of Farrington Hall, I am inclined to believe it.

On the day of my visit, before I was privy to any of this knowledge, I was to meet Mr. Emfinger at the Aldrich Coal Mining Museum, which is located at the old company store. I mistakenly thought it was inside Farrington Hall, so I drove past the museum and went up the hill to the ornate building just across from the store. It was a bone-chillingly cold day, so I quickly grabbed my laptop and headed toward the front door. As I struggled to stay warm, I was relieved to see that the door was already open. I assumed that Mr. Emfinger saw me coming and had opened the door for me. When I ducked inside the door, instead of a warm greeting from the nice man I had talked to on the phone, I found myself in a dark foyer with a door to the left and a door to the right, and they were both closed. Dark basement stairs were in front me. I assumed someone must be inside the building, because no one would leave the front door standing wide open on such a bitter winter day. I called out but got no response. The gloomy basement stairs beckoned to me. Surely Mr. Emfinger was down there and just could not hear me over the fan. I made my way down into the basement and found a light switch. The walls were lined with framed black-and-white photos of days gone by. For a moment, I forgot my predicament. I got lost in a time when cars were ornately trimmed with a decent amount of shiny chrome and most came with fancy hood ornaments. Men took metal lunch pails to work with them, and their wives stayed home to look after the children. I then heard someone upstairs coming in the door. I rushed up the stairs. I was so glad to see Mr. Emfinger waiting at the top, but I could see by his expression that he was not happy. He demanded to know how I got in. Apparently the door had been locked the last time he left Farrington Hall, and he was looking for an answer. Did the ghost of Farrington know I was coming that day? Did he open the door for me? Once Mr. Emfinger was satisfied that I did not pick the lock, he kindly gave me an amazing tour of what has quite literally been his life's work. There was one other thing I noticed during my tour of Farrington Hall that seemed out of place. The room to the left of the main

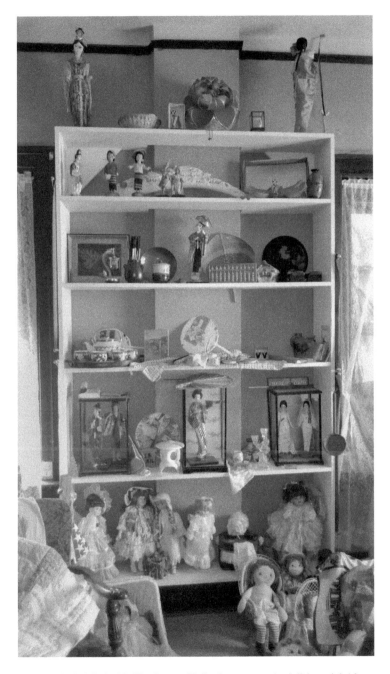

The shelf of dolls inside Farrington Hall where a certain doll (top right) has been known to move. *Author's collection.*

entrance is filled with Mrs. Emfinger's doll and toy collection. Up high on the top of a shelf sits a little Japanese doll dressed in a kimono. For some reason, she is turned around facing the wall, unlike the rest of the hundred or so dolls in the room. When I asked Mr. Emfinger why this was so, he was perplexed. Not only is there not enough room at the base of the shelf to put a ladder to reach the doll and turn her around, but he does not even keep a ladder in the building.

THE DRY VALLEY PATH SPIRIT

Dry Valley Path is located between present-day Montevallo and Calera off of Highway 25 going toward Spring Creek Road. The path sits between two areas that have some of the richest history in the county. Not much is known of this area of the county other than that it was home to several farmers and their families. People led simple lives here and built up a small community on the outskirts of Montevallo. Even a humble community such as Dry Valley is not immune to things that will make your hair stand on end. Numerous people have told the same story over the years of their encounters with the Dry Valley ghost. The son of one of those people is H.G. McGaughy. His father, Herbert, found himself face to face with the spirit of Dry Valley Path one night. Now H.G. is a second-generation storyteller and recounts his father's harrowing tale.

As a young boy of about sixteen, Herbert was walking home late one night from Dry Valley to his sister's house on Spring Creek Road when he had the ghostly meeting. He recounts that a strange lady in a long white dress and bonnet passed by him going the other way. After walking a few feet more down the road, he suddenly realized the odd lady had turned around and was now following him. He looked over his shoulder and got a good look at his pursuer. "She wore no expression on her face, and upon looking at her, she seemed to have

a floating movement about her," he recalls. Herbert picked up his pace a little and continued to check every so often over his shoulder. The woman was still there behind him and seemed to speed up or slow down just as he would. When he reached Spring Creek Road, he stopped and let the woman pass him by. He watched to see where she went. She turned at the driveway of an old house and vanished before his eyes. Herbert had managed to keep his fear in check before this point, but now he ran down Spring Creek Road until he was safe inside his sister's house.

Once Herbert calmed down, he told the story to his sister. She told him that others had seen her too and not just along the road. She had been seen walking down the railroad tracks many times. Who was she? Some believe that she was the wife of a hobo. The hobo had gone to the very same house that she was seen going to asking for food. The hobo entered the house but was never seen again, and people believed that he may have been killed there. Perhaps his body was even buried under the old house, and his wife's ghost went there looking for him night after night. Others argue that the ghost that has been seen is not a woman at all but a man in a long hooded cloak—perhaps the hobo himself. This is one disagreement that will just have to remain unresolved. To find out the true identity would probably leave you just as breathless as Herbert the night he ran down Spring Creek Road.

LEGENDS OF BRIERFIELD

Just a rock's throw from the Shelby County line sits the Brierfield State Park in Bibb County. Five ambitious planters in the year of 1862 sought to build a name for themselves in the iron industry. They picked a site near the Little Cahaba River and, using slave-labor construction, built a thirty-six-foot-high stone furnace and a rolling mill. Despite their lack of experience, the

planters produced a surprisingly high-quality cast and wrought iron. They sold their product to farmers needing metal for plows and other equipment. Production was going well and business was steady, but the high quality of their work had brought them some unwelcome attention.

In 1863, the Confederacy started putting pressure on C.C. Huckabee, manager of the ironworks. He had already signed agreements with the Confederacy obliging it for one thousand tons of pig iron per year for three years and for building a rolling mill. Now it seemed the Confederacy wanted them to sell the whole works or it would be confiscated. With really no choice at all, the planters sold everything to the Confederate States of America for $600,000. Also included in the transaction were "nine slaves, seventy mules, forty one oxen, twenty carts, twenty wheelbarrows and two hundred axes."

After taking over the ironworks, the Confederacy wasted no time expanding the operation. It built a new forty-foot-high brick furnace. It would also need a railroad line to get supplies in and its product out. A line was constructed to connect the ironworks to the mainline of the Alabama and Tennessee Railroad. By 1864, it was producing twenty-five tons of iron per day, most of which was used to make Brooke rifles, an important naval cannon, at Selma. Despite the success of the operation and the amount of money the Confederacy put into it, the furnace was short-lived.

On March 31, 1865, a faction of Wilson's Raiders, headed by Colonel Frederick Benteen, rode to the furnace at sunrise. They met with opposition, but by some reports, the Confederates were simply "driven off without trouble." The same fate awaited Shelby Iron Works and Roupes Valley Ironworks at Tannehill on the same day. The glory days of the Brierfield Furnace site had come to an end. Even though it was rebuilt after the war, it struggled financially and changed owners. On Christmas Eve in December 1894, the furnace's fire was blown out for good.

Mulberry Church

The site of the old furnace has now become a historical state park featuring pioneer-style homes, nature trails and the ruins of the Bibb Naval Furnaces. Several old buildings and log cabins have been moved to the park for visitors to enjoy and to re-create a scene from days gone by. One of those buildings is Mulberry Church. Originally constructed in 1897 near Centerville, Alabama, it was used for regular church services up until 1942. The one-room, twelve-hundred-square-foot building once sat on the dividing ridge between the Cabaha and Warrior Rivers inside what is now the Talladega National Forest.

The church is now a quaint place for small weddings with country charm. It has been beautifully restored with all of its hardwoods polished to a brilliant shine. It appears that a coat of fresh white paint has just been brushed onto the building's exterior. There is one detail, though, that at first glance appears to have been overlooked by the restoration crew. Seven jagged holes in the church door seem out of place, but they have been left there on purpose in memory of a young woman named Penny.

Penny's father was a local moonshiner, and the legend goes that he was not mentally stable, either. Whiskey and mental afflictions never seem to have a happy ending. The people of the town feared Penny's father, and she did too. There was only one thing that could make it all better, and that was starting a new life with her beau. Of course, Penny's father disapproved of her one true love, but that only made her heart yearn for him more. She and her beau planned to elope and get married at Mulberry Church.

Once inside the church, the couple hurriedly exchanged their vows. Once it was done, there was nothing her father could do to stop her from leaving, she thought. Penny's father, however, was drunk again and looking for them. He was not going to let this marriage happen and was furious Penny had disobeyed him. He took his

wagon to the church and drew his pistol. In a drunken stupor, he shot at the church door until his barrel was empty and possibly even reloaded to fire once more. Unbeknownst to him, his daughter was standing just on the other side. The bullets ripped into her delicate body and went straight into her husband, standing on the other side. The young newlyweds both died moments later. People say that Penny still haunts Mulberry Church today. She has been caught on video camera opening the podium doors, which are very securely latched when they are closed. There is no reason for them to open spontaneously, even when the podium is given a bit of a shake.

Jake's Tree

There is an old, hollowed-out tree near the furnace site with a wooden plaque hanging from its trunk. The inscription says "Jake's Tree." The legend of Jake's Tree goes back to the Civil War when a young boy named Jake, probably the age of twelve or thirteen, was too young to go to war but wanted to be like his dad and protect the furnace. When Wilson's Raiders rode into the ironworks on that historic last day in March 1865, Jake saw his opportunity to serve the Confederacy. He fired off a round at the advancing troops and then ducked inside the hollowed-out tree to reload his black powder rifle. Something went dreadfully wrong as he used his ramrod to push the ball down the rifle barrel. The gunpowder ignited, shooting the ramrod out like a piston and bouncing off the inside of the tree and through little Jake multiple times, taking his life. His ghostly presence can still be felt there at the tree today.

PART II

CALERA

THE OLD MAY PLANTATION

Off County Road 42, also sometimes called Roller Coaster Road for its two steep hills, sits a three-hundred-acre farm known as the Old May Plantation. It has rolling hills, lush green grass in the summer and a clear, cold creek that bubbles up through the limestone rock that Shelby County has in abundance. Not much has changed over the more than 150 years the farm has been in existence. It still supports a large herd of cattle, goats and two obstinate mules that the farmer says are more trouble than they are worth. In one of the cow pastures down the road, a mound of dirt, rocks and trees juts out of the ground. Legend says it is a Creek Indian burial mound, and for more than 100 years, farmers have plowed around it and left it untouched. The humble house that sits on the property has had a few upgrades and modifications but still stands on the original, slave-built foundation. Next to the home stands the enormous, pre–Civil War, two-story barn that witnessed some of the darkest history Shelby County has to offer.

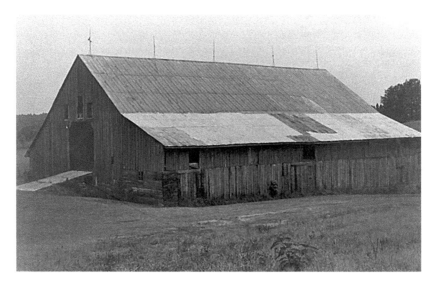

The May Plantation barn, circa 1950. *Courtesy of the Shelby County Historical Society, Inc.*

The history of the May Plantation actually does not start with the May family, though. It was only after the death of its first owner, Robert R. Rushing, that the place came to be known as the May Plantation when Robert's widow married a lawyer by the name of Francis May. They are all buried across the road from the house on a wooded hillside. Another family by the name of Glass is buried there, as well as some slaves in unmarked graves. Robert was one of Shelby County's early settlers. He was known to most simply as "Fox." Fox was quite good with his money and investments. Courthouse records indicate that his personal property and real estate were worth $40,000 in 1860, which would be $500,000 in today's world. He was known to loan money out to fellow farmers who would put land and livestock up as collateral. One such loan on file stated that the borrower only had a ten-day grace period if a payment was missed before Fox could lay claim to his land. If a crop failed, then most likely, the farmer would have no choice but to forfeit whatever property he had used as collateral. Perhaps this is how Fox was able to acquire so much in

just a few years. He made money off the misfortunes of others. Fox looked greedy to some, and this ultimately led to his early demise at the end of the Civil War in 1865.

Times were extremely harsh in Shelby County during the Civil War. There were reports of over 4,100 residents, mainly women and children, suffering from starvation. Adding salt to the wound were bands of armed war deserters plundering helpless families. These deserters took refuge in the wooded hills along the Chilton and Shelby County line, which was sparsely populated at the time. They became such a problem for Shelby County that John P. West of the Second Alabama Cavalry was appointed to lead the home guard to suppress the villainous horde. By the summer of 1864, the number of deserters had grown and reinforcements were sent from the post at Talledega. West's command was inexperienced but spirited. After actively engaging the deserters and arresting several of the thieves, West decided to try his men on a night raid. This proved to be too confusing for the inexperienced crew, who ended up firing on themselves and killing the manager of the Montevallo Coal Company.

After the failure of the night raid, West turned his attention to arresting those who aided the deserters. At least ten residents were rounded up by West's men and never heard from again. Sadly, cruelty existed on both sides as the Confederacy unraveled at the close of the war. In one terrible incident, an entire town was burned down in order to find and kill one fugitive. Thames Lowery, a teenager who did not show up for enrollment into the Junior Reserves, was reportedly shot to death by the home guard on his family's farm. Another woman reported that her husband of only two months, her father and her father-in-law were all murdered by the home guard in a matter of just a few days in early 1865.

However, West was not the one who Shelby County residents blamed. There was a crew known as the Blackwell Crowd that garnered most of the attention. Robert B. Blackwell had fought his own war against Federal troops in Tennessee and had made a name

for himself as a guerrilla captain. He ruthlessly murdered Union prisoners, shot a Confederate officer who tried to enlist him and escaped to Montevallo in Shelby County in the fall of 1864. How he became involved in West's mission to eradicate the roaming bands of deserters we may never know, but perhaps he had come to enjoy the killing as the mutilation of some of his victims' bodies suggested. Obviously, West wanted experienced men to carry out his missions after the mistake that took the life of the coal company manager. Undoubtedly, he was under pressure to do his job right and not make any more costly mistakes.

James Cobb, a local retired Confederate officer, was Blackwell's guide to the unfamiliar territory. It was these two men whom people came to fear and resent the most. Many of the victims of the Blackwell Crowd were Cobb's own neighbors and relatives. The public's disdain for Cobb grew, and it was not long before people were retaliating against the brutality. On June 3, 1865, three men rode to Cobb's home and tricked Cobb into letting them inside before revealing their true mission. They stole all valuables, wrecked the house and rode off with Cobb, who was later found hanging from a green apple tree by his daughters. It was on this very same night that Fox Rushing was dragged from the house that still stands on the May Plantation and lynched as well.

While it is not known for sure if Fox was in cahoots with the Blackwell Crowd, we do know that he was a member of the home guard. He had been arresting deserters, and it is believed that he was killed by the same poor white men who were rising up against slaveholders. Perhaps the seeds of resentment had been planted several years before through his many land dealings and loans that turned out bad for his poor neighbors. Some say that Fox even sold goods to the Union army for gold. He was also accused of giving information to Wilson's Raiders about where his neighbors hid their livestock in order to save his own. Wilson's Raiders were a Union cavalry whose mission was to destroy Southern manufacturing facilities such as Shelby Iron Works,

Tannehill and Brierfield, to name a few. They successfully rode through Alabama and Georgia, sometimes engaging in hand-to-hand combat in order to destroy factories or confiscate arsenals. Wilson's men were victorious in the Battle of Columbus, Georgia, where the ramming ship CSS *Jackson* was burned. It is widely regarded as the last battle of the Civil War.

Wilson's crew burned Shelby Iron Works on March 31, 1865—just a few months before Fox's lynching. If the story of Fox ratting out where his neighbors kept their cattle is true, it would have happened around this time since Shelby Iron Works is only a few miles from his farm. Much like Cobb, Fox would have been seen as someone who profited from the war, so the disgruntled saw fit to violently end his life as well. One version of the story says that he was beaten and hanged from the rafters in the barn that still stands on the farm today. Others say it was a tree nearby that was chopped down when the road was paved many years ago. Members of the Rushing family say that Fox was a good man. They insist his hanging was unjustified because he was known to feed orphans and starving neighbors. The truth will remain a mystery, but one thing is for certain—Fox frequently lets people know that he is still around the farm today.

Shadow people, cold spots and objects being moved are just some of the things that the residents of the old farmhouse have experienced. A woman and her boyfriend who used to live in the home tell the story of how one cold January morning a few years ago, she woke up very early to go to work and could not find her gloves where she had left them the night before. She looked all over the house and finally resigned herself to the fact that she would have to go without them. She walked outside to start her car and saw her gloves sitting on the roof of the car. She thought to herself that it was quite odd, but perhaps she had left them there all night in the freezing temperatures and just did not remember. There was only one problem with that theory—when she slipped the gloves on, they were toasty warm inside! She chalked it up to Fox playing a prank on her.

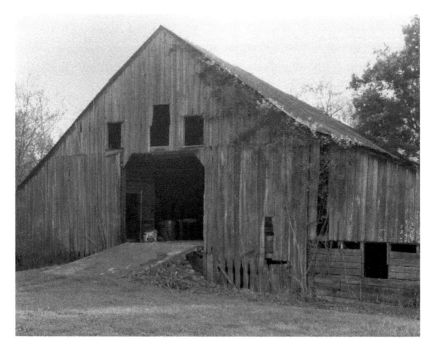

The May Plantation barn as it stands today. Numerous phantom faces have been photographed here. *Author's collection.*

The current resident believes Fox's violent end has something to do with his goats being spooked too. When he moves them from one pasture to another, they must walk past the farmhouse. They almost always get spooked at the same spot behind the house for no apparent reason. Perhaps the horrible events that took place can still be felt by the animals. Inside the barn, it is not unusual to capture phantom faces in digital pictures or see a tall shadow of a man. One person has even heard the unmistakable thundering sound of distant cannon fire while standing in the barn. Perhaps it was coming from Shelby Iron Works just down the road as the ghosts of Wilson's Raid played out the skirmish once more and recounted the events that led up to Fox being hunted down like the sly animal he was named for.

THE SHELBY SPRINGS MANOR

The first time I crossed over the railroad tracks and passed through the gates of Shelby Springs Manor, I knew I was in store for something truly extraordinary. A rare Alabama snowstorm coincided with my appointment with Mrs. Carolyn Dorris at her enchanting estate. With big snowflakes falling, a quaint old cottage greeted me at the entrance. Ponies grazed behind white fences as I drove around to the front of the grand three-story 1920s home. A waterfall to the right coming from one of the many springs was a nice surprise just before the end of the drive. Mrs. Dorris welcomed me and my friends inside and then, like a true southern lady, would not let us leave until we were full on corn bread and chili. We talked of history and ghosts of the Civil War by the warm fireplace while the snowstorm swirled outside. We took a tour of the home and rode in the elevator—Shelby County's first back in the day. We learned that the basement was the only thing still original to the previous structure. The house that stands today does so in the footprint of what once was Alabama's finest hotel and resort.

It is speculated that the history of Shelby Springs goes back to the year 1540 when De Soto came through Alabama. It is said that De Soto visited the Creek Indian town of Cosa just ten miles from Shelby Springs. Given the importance of the healing waters of Shelby Springs to the natives, it is believed by some that De Soto and his men would have been brought here to refresh and replenish their weary bodies. It is thought that the Native Americans regarded the springs as hallowed ground and used them for ceremonial purposes. Even today, an occasional visitor will ask Mrs. Dorris if they can take home a jug of the magical water to treat aching bones. The land at the crossroads of Highways 42 and 25 near Calera boasts six natural springs. Some of the springs are sulphur, one is limestone and the rest are chalybeate. Around the year 1839, a resort was built at the site of the springs, and it soon became a summer paradise for wealthy planters.

The Shelby Springs Manor as it stands today. *Author's collection.*

Vacationing ladies enjoy a tree swing on the lawn during Shelby Springs' resort years. *Courtesy of Mrs. Carolyn Dorris.*

The resort is remembered fondly in a letter written by Ben Lane from Virginia in 1872:

> *One o'clock—Shelby Springs! Twenty minutes for dinner. A leather colored orator gives us a gushing description of the charms of the place, and the niceness of the dinner. And a band of Ethiops, with wind instruments, give us a blast of salutary music…Most of us walk to the springs, and survey the premises. They look clean and cool, and there are worse places in the world than Shelby Springs, etc. Ah me! What memories do Shelby Springs recall! This day sixteen years ago, I was here, with ever so many beautiful girls, and how we danced, and carried on, and loved a little, and parted and forgot! And in a year or two they all went—some to the bridal, some to the tomb.*

It remained a resort until 1915 with a several-year stint as a Confederate training camp, Camp Winn, and hospital during the Civil War. The peaceful site escaped much of the violence that the war brought to the South. Tucked away in a quiet valley, it did not see the horrific results of the fighting until near the end of the war in the summer of 1863. The resort was taken over to be used as a Confederate hospital after the fall of Vicksburg, much to the chagrin of the people who were already taking refuge from the war there. Sister Mary Ignatius and Father Leray led a group of nuns called the Sisters of Mercy who cared for the sick and wounded soldiers in Vicksburg. They endured over a year of shelling by Union naval forces at Vicksburg, scant food and an outbreak of yellow fever.

The Sisters of Mercy were a religious order that was founded in Ireland. They ministered to the poor, sick and ignorant. The first of them arrived in the United States in 1843 at the invitation of a bishop in Pennsylvania. From there, they settled in New York and San Francisco. They found their way to Mississippi due to the large population of Catholics in the port city of Vicksburg. Father Leray and the sisters set up schools and taught classes before the outbreak

of war. Once the war began, Vicksburg was pulled into the chaos very quickly due to its important position on the Mississippi River. If Vicksburg fell, transportation on the river would cease and the fall of the Confederacy would certainly be next.

The people of Vicksburg held out as long as they could against the Union. It is reported that conditions were so poor at one point that citizens ate dogs and rats to stay alive. It was these types of conditions and the intense shelling that caused the sisters and Father Leray to flee in 1863. They saw their hard work and efforts burn and crumble. They had to move numerous times to stay safe. Their schools and even their cathedral were destroyed by fire. They boarded boxcars not knowing where they would end up. Their train made stops in Demopolis and Selma, but it was the resort at Shelby Springs that caught the eye of Dr. Brickell, who was traveling with them.

The sisters prepared the main resort building and a long line of cottages for the soldiers. They turned the ballroom into a surgical ward. There were accommodations for three hundred patients and comfortable quarters for the staff. No doubt the numerous springs played a part in Dr. Brickell's decision to stop here. He could use them to rehabilitate the soldiers.

Finally away from the front lines of war, the sisters and Father Leray tried to make the best of what little they had. They survived on half rations and sometimes had none at all but would still pray at meal time like there was something to eat. Father Leray made altar wine by squeezing grapes into a tub and made shoes for the sisters out of rabbit pelts. Lack of provisions was not their only challenge. Many of the sick and wounded would not let the sisters near them because their Protestant upbringings had taught them to think badly about nuns. They won over their hearts, though, one by one with their gentle nature and knack for soothing what ailed the soldiers.

Over nine hundred soldiers traveled by train to the hospital at Shelby Springs during the war. Sometimes their travels were perilous, as recalled by Sister Ignatius, who witnessed wildcats attacking the wounded when the smell of blood drew them near on one trip. The sisters and Father

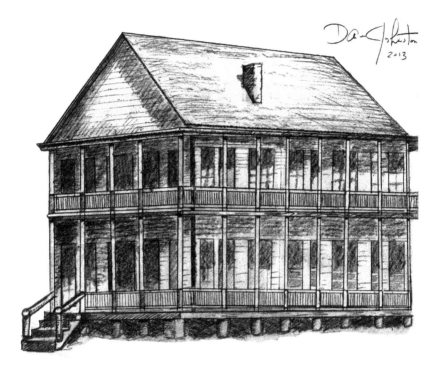

An artist's sketch of what the Shelby Springs Hotel looked like during its time as a Civil War hospital. *Courtesy of Dan Johnston.*

Leray were nothing short of heroic in their efforts. They often went without so their patients could have what little food was left. Sister Teresa Newman was so dedicated to the effort at Shelby Springs that she made her profession of faith there, committing herself to the cause for the rest of her life on a makeshift altar with sycamore balls burning in lard oil instead of the candles that would normally be used.

Both Jefferson Davis and Abraham Lincoln recognized the sisters' efforts. Davis wrote, "I can never forget your kindness to the sick and wounded during our darkest days." Lincoln met with a determined Sister of Mercy once who went over the heads of the administrators in the War Department to tell him of the lack of food for the wounded. Her courage caused Lincoln to write a presidential order that the Sisters of Mercy would have whatever they needed to care

for the soldiers and it would be charged back to the War Department. Lincoln had this to say about the sisters:

> *Of all the forms of charity and benevolence seen in the crowded wards of hospitals, those of the Catholic sisters were among the most efficient…As they went from cot to cot distributing the medicines prescribed, or administering the cooling, strengthening draughts as directed, they were veritable angles of mercy.*

Angels they most certainly were, and Mrs. Dorris believes one of them may still be watching over the residents of her home. On a Christmas Eve some years ago, her granddaughters were staying over for the holiday. On a whim around the stroke of midnight, they decided to play dress up in their grandmother's old collection of evening wear. The girls laughed, had fun and snapped pictures with a cellphone camera while everyone else was fast asleep. Mrs. Dorris loved the photos and had them enlarged. Upon doing so, she noticed that in every picture, there appeared to be a nun, complete with a nun's habit, standing in the window behind her granddaughters. Maybe Sister Ignatius was trying to tell the girls it was time for Christmas midnight Mass and not time for such silliness. Or perhaps it was the dedicated Sister Teresa who loved Shelby Springs and was very popular with the other sisters for her storytelling abilities.

Ghosts from the past at Shelby Springs were nothing new to Mrs. Dorris. She had seen one with her own eyes one day while the home was being renovated. She was out in the pasture feeding the horses on a day when the workers were off. She looked toward the house and saw a man in a black coat pacing nervously back and forth in her driveway in front of the home. She quickly finished up what she was doing to see what the man needed. She thought that maybe the renovators had decided to work that day after all. When she got to the front of the house, the man had vanished. She walked inside to ask her sister what the man had wanted, but her sister was perplexed and had not seen anyone at all.

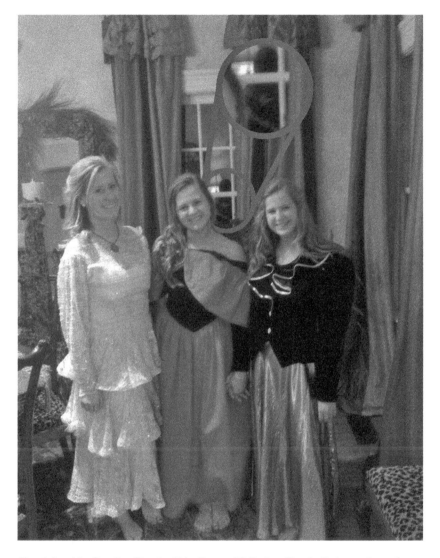

From left to right: Caroline Dorris, Abby Lee and Julie Ann Dorris. Is that a ghost of one of the nuns in the window? *Courtesy of Caroline Dorris.*

The old groundskeeper, Mr. Jewel, while never having seen a ghost, did come across a gruesome discovery one day in the woods behind the old home. He was digging up some dirt to use on another part of the property when he came across an apparent dumping site

for the numerous amputated limbs the doctors must have removed from wounded soldiers. With more than two hundred deaths having taken place at the hospital, it should come as no surprise that there have been other ghosts experienced here. The young nephew of Mrs. Dorris's maid also experienced a ghost at the home. He was playing in the basement and came running up the stairs in a fright. When he was asked what was wrong, he explained that a ghost had run past him and knocked him down. My own visit with Mrs. Dorris caused quite a stir when I shared photos with her that I took in front of the home with my friends before departing on that snowy day. In the upstairs window on the right side of the house, despite no men being present in the home, there appeared to be a man with a handlebar mustache peering out at us.

Shelby Springs Confederate Cemetery

The silent dead, the silent dead
I've lingered where they sleep in peace
Where care, and want, or thought of dread
There anguished vigils cease.
—Sister Mary Ignatius

On a hill less than a mile from Shelby Springs Manor sits the quiet resting place of more than 200 Confederate soldiers who died after being sent to the hospital by train. They were from all over the South. The graves of 212 are marked Unknown Soldier, C.S.A. For more than one hundred years, the graves sat unmarked with only a sunken outline in the earth as a reminder of what remained there. In 1987, the Shelby County Historical Society restored the cemetery and added a memorial to the sisters and Father Leray.

There are a few private family burials inside the cemetery, as well as some soldiers who died during training when Shelby Springs was being used as a Confederate training camp. If you walk into the woods

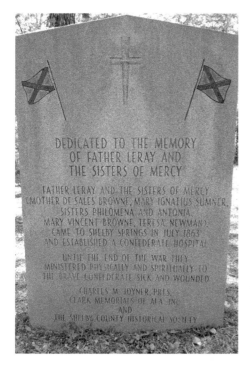

DEDICATED TO THE MEMORY
OF FATHER LERAY AND
THE SISTERS OF MERCY

FATHER LERAY AND THE SISTERS OF MERCY
(MOTHER DE SALES BROWNE, MARY IGNATIUS SUMNER,
SISTERS PHILOMENA AND ANTONIA,
MARY VINCENT BROWNE, TERESA NEWMAN)
CAME TO SHELBY SPRINGS IN JULY 1863
AND ESTABLISHED A CONFEDERATE HOSPITAL

UNTIL THE END OF THE WAR THEY
MINISTERED PHYSICALLY AND SPIRITUALLY TO
THE BRAVE CONFEDERATE SICK AND WOUNDED

CHARLES M. JOYNER, PRES.
CLARK MEMORIALS OF ALA. INC.
AND
THE SHELBY COUNTY HISTORICAL SOCIETY

Left: A memorial at Shelby Springs Cemetery dedicated to Father Leray and the Sisters of Mercy. *Author's collection.*

Below: A vortex-shaped anomaly caught on camera at the Shelby Springs Confederate Cemetery. *Courtesy of Triple J Ghost Hunters.*

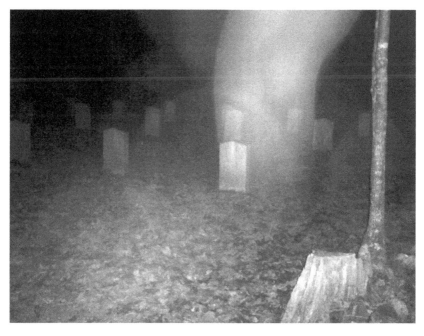

at the end of the cemetery, you'll find a few more unmarked, sunken earth sites that are probably graves as well. Legend has it that these are the unmarked graves of Union soldiers, and their restless souls, unhappy about being buried in enemy territory, haunt the cemetery late at night. Unexplained lights in the woods have been seen in the area of these graves. People have also reported seeing the ghost of a redheaded Confederate soldier wearing a grey coat roaming about the cemetery just before sunset and shadow figures. One person who had stopped to read the gravestone of a Mr. Stephens felt her arm tugged on by something unseen while she stood there. This may be the soldier's final resting place, but I have a suspicion that some are not that restful. Perhaps being buried so far from home has caused some disturbance for these souls, or maybe the ones with no grave markers are making a simple request.

PART III

HARPERSVILLE

GHOSTS OF THE CREEK TRAIL OF TEARS

After the Battle of Horseshoe Bend in 1814, there was a population explosion in the Southeast of non-Indians. In 1810 there were only about nine thousand white people across Alabama and Georgia. By 1830, there were over three hundred thousand. The Creeks were unwilling to sell their lands, so more often than not, settlers would squat on land that was not theirs. Sometimes prospectors could be found taking samples of the earth and surveying land that they did not own. If they found something of value, they would forcibly remove the Indian families and start a business. Fraud was rampant as well. The practice of shady land deals meant to trick natives out of land was actually brought to President Andrew Jackson's attention and investigated by Francis Scott Key, writer of the national anthem. He found whole towns springing up on Indian lands and documented numerous cases of deceptive land deals. The state of affairs across Alabama and Georgia was out of control. The president would have to address

the problem somehow. Tensions were mounting, and it was up to him to devise a solution.

Jackson's response to the situation was the Indian Removal Act of 1830. Despite pledging that this removal would be on a strictly voluntary basis, nearly all relocation was handled by military escorts and against the will of the people. It is an ugly part of Alabama's history that was characterized by Jackson as "just" and "humane." One can hardly imagine the displacement of fifteen thousand Creek Indians, starvation, mistreatment and horrifying numbers of deaths as being described as humane. For thirteen years, some sixty thousand people belonging to Creek, Choctaw, Chickasaw, Cherokee and Seminole tribes continued to be rounded up across Alabama. Many were forced at gunpoint to take the trails that ultimately led them west. Greedy white settlers and prospectors took possession of their lands either by squatting or forcibly removing families from their dwellings. An uprising by the Creeks in 1836 led to even more violence and added fuel to Jackson's campaign to remove them all.

All told, a shocking 3,500 Creek Indians died in the Second Creek War between 1836 and 1837 alone in an incident that most history books rarely mention. If it is mentioned, its significance is downplayed as a police action and not a real war. It is not hard to imagine whole families possibly wiped out, while others were separated in the chaos, never to see each other again. The Second Creek War was started in part because of the Treaty of Cusseta, which was signed after a plea from Opothle Yohola, a Creek chief, to President Andrew Jackson for protection went unanswered. The treaty divided up Creek lands into individual allotments for each head of household. They could either sell the land to move west or stay and submit to state laws. The treaty was supposed to put an end to the squatting and the land speculators harassing the Creeks. Sadly, that did not happen.

The waves of new settlers did not stop, and neither did the attempts to fraudulently take the Creeks' lands. Many Creeks did not understand that the paper title they were given for their land was proof of ownership that they would need to keep it safe. They

were either cheated out of house and land or simply lost the paper title altogether. Three years after the Treaty of Cusseta was signed, countless Creeks were impoverished and homeless again. By 1836, the Creeks had reached a level of frustration that only bloodshed could satisfy in their minds. They were ready for an uprising against the government and white settlers once more. Their first target would be white settlers encroaching on their lands in Roanoke, Georgia. They killed entire families, destroyed farms and burned the town to the ground. After years of suffering injustices and seeing their own people die at the hands of the whites, their vengeance was unmerciful. After a few early victories, the Creeks became ever bolder, but their triumphs would not last.

In February 1837, a large party of Creeks took refuge in the swamps of Pea River after their concentration camp had been attacked by white militia units while they were there waiting to be sent west. Men, women and children had no choice but to hide. There was nowhere to go. Outraged and needing supplies for their families, several of the Creek men started striking farms on the borders of the swamp. It didn't take long for the military to gain word of these strikes and to start pursuing the Creeks. A sizeable military force was sent to deal with them, led by Brigadier General William Wellborn. He learned that there was a large camp of Creeks near Hobdy's Bridge and ordered his men to run at full speed through the mud and water at the camp. The Creek warriors fought aggressively against the troops so that their wives and children could escape farther into the swamp. Some of the women reportedly took up arms and fought back as well but died in doing so. The Battle of Hobdy's Bridge was the last battle of the Second Creek War in Alabama. Not all of the Creeks who left Alabama faced such violence, but their journeys were difficult nonetheless.

The first waves of immigrants to go west were part of the William McIntosh tribe. They did so voluntarily after a minority of leaders inside the Creek Nation, including William, signed the Treaty of Indian Springs. William McIntosh was the Coweta headman,

and with a single stroke of his pen, he signed away three million acres, which included all remaining Creek land in Georgia and a large portion in Alabama, to the federal government in exchange for a large sum of money plus territory in present-day Oklahoma. McIntosh might as well have signed his death warrant. He angered the vast majority of the Creeks who opposed the fraudulent Treaty of Indian Springs. What he did was punishable by death under the laws of the Creek Nation, and his sentence was ultimately carried out. It may seem that McIntosh sold out his fellow people, but not everyone was against him. He had over three thousand followers who wanted to leave Alabama. They had already been pushed off their lands in Georgia and had been living hand to mouth. They were miserable from starvation, and their pleas to the tribal council fell on deaf ears, it seemed. While the decision was not taken lightly, the leaders of the Creek Nation decided they would rather see their people suffer and die on the land of their ancestors than to move.

It was not long before a party was sent out to execute McIntosh for his betrayal. His son Chilly escaped and started planning to fulfill his father's mission. Harpersville was the chosen rendezvous spot for all the families that wanted to travel west because it was far enough away from the hostility that brewed against him inside the Creek Nation. They originally planned for a September departure in 1827, but delays pushed them into November, when the first of winter's frost nipped at their fingers. Government agents met with them at Harpersville to take a muster roll. The men were given blankets, rifles and knives. Agents had hoped to receive as many as 3,000 people but only 703 people were counted, including slaves. On the night of November 9 or possibly 10, the party moved out of Harpersville going north with federal troops escorting them part of the way at gunpoint to get the point across that they were no longer welcome. Thus their long journey had begun, and it would not be easy in the dead of winter.

Sickness ailed the women and children in Tuscumbia before they could even leave the borders of Alabama. The group split into

two parties. Some traveled by land and others by boat. Each group encountered great difficulties. Swollen rivers made waters difficult to navigate, and muddy roads made it impossible to travel by wagon. Belongings were left on the roadside. By the time the two groups made it to Fort Gibson in 1828, they were nearly broken of spirit and had buried some of their loved ones along the way.

Undoubtedly, other groups of natives were marched through the town of Harpersville over the thirteen years that the Indian Removal Act was enforced. Perhaps some of the three thousand Creeks who were held at Fort Williams in 1832 passed through here on their way to the fort that once stood nearby. Fort Williams served as a supply depot before the Battle of Horseshoe Bend, and it is where Jackson returned to after the battle. The cemetery associated with this fort is the resting place of over one hundred militia who fought valiantly in that historic struggle. There are others who are buried here, though in unmarked graves. The cemetery also holds Cherokee allies who fought with Jackson at Horseshoe Bend. There are also an untold number of Creeks who died of starvation and sickness while being held against their will at Fort Williams while it was being used like a concentration camp during the Trail of Tears. Creek mothers helplessly watched their children die because there was no food to eat. Husbands watched their wives grieve themselves into the ground. The despair of these people must have been so tremendous. Inadequate provisions had been sent by the government to keep the thousands of people held at the fort alive. Bands of angry Indians who were against immigration were known to burn stores of provisions as well during this time, making matters worse. They would rather see their fellow tribesmen and women die than to be forced off the land that was theirs.

As if this truth about Alabama's history is not foul enough, I'm sorry to say it only gets worse. The Fort Williams Cemetery sits along the Coosa River and has beautiful waterfront views. In recent years, the property value of the land has skyrocketed. Couple that with the fact that in 1930, an effort to get the United States Congress

to protect the cemetery failed in the House of Representatives, and you might start to see where I'm going with this story. In 2006, a residential developer relocated the headstones and renamed the area Riverbend. Inside the housing development, you will find Memorial Garden, where the headstones have been placed, but there exists no record of any human remains having been moved. Driving by the original location of the cemetery, $500,000 homes now stand instead of the grave markers. Underneath their foundations lie Trail of Tears victims, brave soldiers who fought for their country and even the personal friend of Andrew Jackson, Captain Andrew Gibbs. It is sad to see that the same lust for valuable land that ultimately led to the death of these people has now desecrated their final resting places. Those Cherokee allies who fought for Andrew Jackson, now betrayed by him, must be even more restless in their graves than before, but it is not the Cherokees or the ghosts of the militia that I have been told of. It is the ghosts of the weary and downtrodden that the people of Harpersville speak of today.

Perhaps it is some of McIntosh's followers who are seen marching through the streets of Harpersville late at night on the anniversary of their departure. The women are seen with their babies strapped to their backs and sometimes small children at their sides. They are in traditional native dress. Some Indians might be on horseback and others in wagons. Their faces show the despair and anguish they have been through as they float by, staring straight ahead. Perhaps they are part of the McIntosh group, or it could be the Creeks who were rounded up and detained at Fort Williams some years later. Their fate was worse than the McIntosh group's, and even today they are not allowed to rest peacefully. Whichever the case, it is a sad sight to behold, according to those who have witnessed it. It supposedly happens every year in the small town, but the exact night of its occurrence seems to be as mysterious as the identities of the ghosts themselves.

Alabamians would probably like to keep the ugly truth of what happened in the past and what continues to happen presently swept

under the rug—or buried under the homes in a new waterfront subdivision, you might even say. It is time to pull the rug back and face what's really been hiding beneath it all these years. I am disturbed by what I discovered at Fort Williams Cemetery. Let us use it as a lesson and a reminder of what will become of our historic landmarks if we do not seek to protect them and if we are not vigilant in the plight. A great way to protect historic landmarks is to support your local historical society, such as the one in Shelby County.

The Legend of Chief Boz Shepard's Grave

During the tumultuous time that came for Indians in Alabama after the Battle of Horseshoe Bend, Chief Boz Shepard lived on a large portion of the land that is the present-day town of Shelby. His land extended toward Chilton County to the south and all the way to Sylacauga in the east. Back in those days, it was called Kewahatchie. Today, the general area of where the Kewahatchie town center and his homestead stood is in the vicinity of Shelby Iron. The only reminder of what used to belong to Chief Boz Shepard is a spring named after the land that was stolen from him by murderous prospectors.

Chief Boz Shepard was from the prestigious Cloud Clan of Cussita Indians from the Chattahoochee River area. His grandfather was Mico Chief Tussekiah, who passed down the oral history of their people. They had come from the West near the Little Colorado River. They left their town and were joined by Coweta and Chickasaw Indians as well. These broken tribes united together and became what are known now as the Creeks. They were divided into Upper and Lower Creeks because of their geographic locations across the Southeast. They also divided the land into squares for each man. Some of the towns were redstick or war towns, and others were white towns or peaceful places of refuge. They considered white towns sacred. Chief Boz Shepard came from a white town and was a peaceable man. Both his father and grandfather protested when the American

government put a military arsenal in the town of Cussita. They felt that their town, a place of refuge, had been desecrated by the stores of guns. Mico Tussekiah went to his grave not ever seeing the guns removed from his town. His son, Chief Squire Cloud, continued the quest to have them removed. He pleaded to the soldiers in English, "What is this you preach? All men equal with rights of freedom. Why do you not practice what you preach?"

It made Chief Boz Shepard nervous though when he saw white men coming onto his land day after day taking samples, digging and measuring. He had no doubt seen time and time again how other tribes had been pushed off their lands and forced to go West by this point. Alarmed, he told William Falkner, a white man with whom he was good friends, what was happening. William was sympathetic and considered Chief Boz Shepard a part of his own family. He even offered up his own home in case something was to happen to the chief's. William caught word that the prospectors were planning to stage a herd of horses being stolen. The intention was to blame it on the great chief and call it an uprising so they could take over his land. Unbeknownst to the chief and William, a rich seam of ore had been found running through Kewahatchie.

William tried his best to foil the plan. He let the horses out that the masked prospectors intended to steal. The chief hid in the forest with his gun cocked when the masked intruders rode in. When they did not find any horses to steal, they were thoroughly angered. In a rampage, they started firing shots in every direction. It scared the women and children who were hiding in the various buildings around the compound. One of the women ran out to plead with them to stop before the innocent children got hurt. She was shot dead in cold blood and laid on the ground with her hands outstretched before her still begging for mercy. Chief Boz Shepard darted from the woods firing his gun when he heard the commotion to try and save his loved ones. He, too, was gunned down. Another one of the braves from the family heard the gunshots from the river and rode his horse back as fast as he could to help, but he was shot dead along with his horse.

Before leaving the scene, the cold-hearted men set each of the cabins on fire with the chief's wife and young children inside.

Black smoke filled the sky, and flames could be seen leaping above the trees for miles around. William's heart sank as he rode into Kewahatchie and found the whole town torched. He found the body of his friend, the chief. As he tried not to choke on the thick smoke, a faint cry came from one of the smoldering cabins. He rushed over and searched through the ruins. Beneath a charred bed he found the lone survivor, the chief's eight-year-old daughter, Fadora. Beneath another bed he found Fadora's mother and two siblings dead. Six family members in all died at the hands of the prospectors that day, and no one, not even William, could do anything about it.

The family was all buried together in the Harpersville Cemetery. Legend says that the granite rocks that surround their graves were brought there one by one over the years by visiting family members and friends. Slowly over time they have built the wall with rocks from the Coosa River. Even today, nearly two hundred years later,

The grave site of Chief Boz Shepard and family in Harpersville Cemetery. *Author's collection.*

sometimes a new rock will mysteriously show up along the wall as if the ghosts of the Cloud Clan still stop by to visit.

After the family's death, the rest of the braves living at Kewahatchie immigrated to present-day Oklahoma, except for little Fadora. She was left with William, who was told that someone from the Cloud Clan would return for her after they relocated. Fadora never went to Oklahoma though. She stayed in Alabama with William acting as a father figure and providing protection. In William's mind, it was probably the least he could do since he could not save his friend and the rest of the family. Fadora eventually fell in love and married an Indian who died as a Confederate soldier in the Civil War. When she found herself without a husband and needing protection once again from the hatred of Indians that still simmered, she moved back to William. He eventually took her as a wife even though he was much older than she and she had a hard time seeing him as anything but a father figure. Fadora had several children with William but died

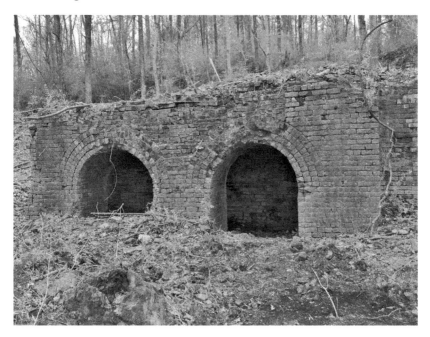

The old Shelby Iron Work's coke ovens. *Author's collection.*

at age forty-nine. Fadora Cloud Falkner is buried in Old Sterrett Cemetery off Highway 25.

After clearing Kewahatchie of the Cloud Clan, the greedy prospectors had much success with their enterprise, Shelby Iron Company. They began mining and laying railroad tracks through the deserted Kewahatchie. The railways gave life to the Shelby Springs Resort and to a quaint hotel with a white picket fence next to the iron furnaces. Shops sprang up and were connected by a long wooden boardwalk. Homes were built for the workers. Now, most of the stores and homes are gone. What does remain is in shambles. No matter what becomes of the town of Shelby in the future, in my heart, it will always be Kewahatchie and belong to the prestigious Cloud chief whose family came from the river out West.

GHOSTS OF THE CHANCELLOR PLACE

It was during the time of slavery, around the 1840s, that the Chancellor family came to Harpersville. They purchased a home and land on the road that is now Highway 76. It has been said that at one time, all you could see for miles from the porch of the house was cotton fields. The Coosa River borders the back of the farm, so in addition to growing cotton and corn on their thousand or so acres, the family owned and operated a ferry as well. For five generations, the dogtrot home has been passed down and is presently owned by a descendant of William S. Chancellor named Barbara Adkins. The home was bequeathed to Barbara by her great-aunt Patsy under one condition: Patsy requested that Barbara move into the home the very night of her passing. Barbara agreed, kept her promise and thus began a long journey to painstakingly restore the neglected home.

The first time I visited the Chancellor place, I was struck by how beautiful the flower gardens were. Unbeknownst to me at the time, the flowers hid several small graves of children who had died in a flu

The Chancellor House long ago, before Barb Adkins renovated. *Courtesy of the Shelby County Historical Society, Inc.*

epidemic. Their parents had been sharecroppers at one time long ago. The inside of the home was simple, clean and kept true to its humble past as a farmhouse. It was no surprise to me when I came across an article in *Cooking Light* magazine that featured the inside of the home as a beautiful backdrop for festive holiday treats and mentioned the much-loved annual Christmas open house hosted by Mrs. Adkins. The warmth and beauty of this home made me curious about the people who had lived there many years ago and curious as well about the ghosts that have long been rumored to haunt the farm.

William S. Chancellor was the first generation of the Chancellors to live in the home. Although William did not consider himself wealthy, he was well-off enough to own sixty slaves to help in the fields and in the house. He had not always been so fortunate. Several bad investments in his younger days had caused him to twice lose land and start over. It seemed, though, that he had learned from those mistakes and his new farm would be his legacy. In addition

to raising cotton, he ran a ferry across the Coosa for the people of the community.

A married couple lived in a cabin down by the ferry. They were responsible for the day-to-day operations in exchange for a portion of the fees collected. At night, passengers needing a ride across the river would ring a bell outside the cabin to wake them. Near the turn of the century, President William McKinley even took a ride on Chancellor's Ferry during his tour of Alabama. When cars became a common mode of transportation, it proved to be somewhat of a challenge for the ferry operators. In learning how to cross a car on the ferry successfully, sometimes accidents would happen. Chancellor's Ferry was no exception. One day, a car tipped over the side and drowned a little girl inside. The Chancellors, out of compassion, gave the grieving family money for her burial.

Running a ferry was not the only thing that William was known for in the community. He was also known for having some of the finest horses and treating his slaves very well. Unlike some slave owners, William instilled in his children the belief that the slaves were family and that they should always treat them kindly. William particularly liked a young slave boy named Tosh who was born on the farm and was the son of the house's cook named Sue. Tosh's only job was to fetch William's horse from the pasture and saddle him. The rest of the time, Tosh just followed William around. Even though little Tosh never could quite figure out how to saddle a horse properly and the saddle ended up on backward more times than not, Mr. Chancellor would always make it right and chuckle. He also made sure Tosh was given extra helpings of food at dinnertime. People who know the family grin and say that the little slave boy never worked a hard day in his life because he was so well liked by William.

After the Civil War, Tosh and his family stayed with the Chancellors, despite having been freed. The bond that had developed between the families extended beyond just William and Tosh, however. Tosh, who eventually raised ten sons and three daughters at the Chancellor place, lived to be 104 years old. When William passed away, he left

the farm to his son Isaac, who raised a family there as well. One of Isaac's daughters, Patsy Chancellor, was the one who bequeathed the place to its current owner. Patsy had been raised in the same manner as her father was. She too had been taught to respect the blacks who helped them on the farm and in the house. Patsy, who had a passion for music, had fond memories of going down to the barn after the workers came in from the cotton fields to listen to them sing. Sometimes her father, Isaac, would invite the workers into the home to dance while he played records for them on the Victrola. Patsy later recalled how much she admired the black families whom she grew up with and their life philosophies. The Chancellor family was so well loved by their workers that they were often invited to weddings and other family gatherings. One of Tosh's sons, named Tot, also lived on the farm his whole life, just like his father had. Tot and Patsy shared a close, lifelong friendship, just as William and Tosh had.

Patsy was encouraged to continue her education after graduating tenth grade in Childersburg. She left the farm to attend boarding school in Athens. She dreamt of studying music abroad one day. She became fluent in German and majored in music. Her father encouraged his workers to get an education too. He let them take his mule and wagon out in the evenings to attend a school near the Wallace Plantation. During Patsy's last year in Athens, tragedy struck back home at the farm. Her youngest brother was accidentally killed by a mule one day after plowing fields. He forgot to remove the harness chain, and as he rode the mule bareback on the way home, the mule spooked. The fifteen-year-old boy's foot got caught in the chains. Sadly, he was kicked, stomped and dragged to death before a neighbor could stop the frightened animal. Patsy felt it was her duty to return home and help her father through this difficult time, so she put her dreams on hold.

Patsy did eventually finish college and became a teacher. She taught in Bessemer for a number of years as well as in Vincent. She married once but had no children. Her husband, a veteran of World War I, began to lose his mind after returning home from the war,

possibly due to the effects of being gassed. He tried to strangle her at times and even held a gun to her head for several hours during one episode. She had no choice but to have him committed. Many schools during that time would not hire married teachers, so in order for her to continue teaching, she had to get a divorce. She never dated after that and returned home to the farm once again after her father's death. It was then that her friendship with Tot, who came to her aid after all her siblings had died, really meant the most.

Despite Isaac Chancellor's encouragement to his workers to get an education, Tot Chancellor never did learn to read and write. He died in 1985 and is remembered by all as being jovial. "He loved to laugh," says Harpersville mayor Theo Perkins, who is a relative of Tot's. Mr. Perkins remembers Tot playing jokes on people and teasing his grandmother about things that had happened years ago. Barbara Adkins's son, Chancellor "Chan" Stone, remembers sitting in Tot's lap and riding with him on the tractor when he would visit his great-aunt Patsy. Tot would joke that Chan was named after

Tot's house. *Author's collection*

him. He lived in the small cabin behind the main house, which still stands today. He was married once, but when his wife insisted on leaving Harpersville to pursue a better life for herself and their son in Memphis, Tot refused to leave the Chancellor place. He was fiercely loyal and very much loved for that. Patsy depended on his help heavily, especially during the years leading up to her death. Because Tot did not have a phone, whenever Patsy would need him, she would stand on the back porch and call out, "Woooo Tot!" To let Patsy know that he was on his way, Tot would shout back, "Woooo Pat!" in return. A comment was once made to Patsy about how she would probably live to a ripe old age since her father and grandfather had both done so. Patsy replied, "Oh, I could only do that if I have Tot with me." Patsy could not imagine her life without her friend Tot, and I glean from listening to recordings of the two talking about the good old days that Tot felt much the same way. Patsy died four years after Tot was laid to rest.

The very night of Patsy's death, Barb Adkins, her husband and her son Chan moved into the Chancellor home. Chan was only about ten years old at the time and remembers not being able to sleep very well in the old house. Patsy had only just died hours before in the very room that they all were sleeping in. Every bump and creak inside the old house made Chan uneasy. Knowing that the children's graves were just outside the window where he slept also caused him a bit of trouble. His fears eventually subsided though as he adjusted to country life. Chan had moved from the city of Homewood to Harpersville, which was a bit of a culture shock, to say the least. He learned to enjoy quail hunting, though, with his dog on the farm.

On one such occasion when he was fifteen years old, he walked down the road that cuts through the farm toward the old ferry. It was late in the afternoon, and the sun was beginning to set. When he got to the bottom of the hill, his dog stopped dead in his tracks. Chan looked down the road to see what had his dog's attention, and there was Tot walking across the road in front of

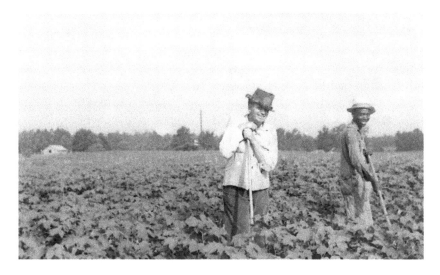

Tot Chancellor (right) stands in a field near Four Mile with Walton Dorough during the Depression. *Courtesy of Theo Perkins.*

him. The shadowy figure was tall, skinny and a bit hunched over. There was no mistaking the identity of the ghost. Tot stopped in the middle of the road, turned and looked at Chan for a moment and then continued walking into the woods where he vanished. Frightened, Chan ran back home and told his mom. She was not surprised that Chan had seen Tot. As a matter of fact, several people, including Patsy, had heard Tot calling from his old cabin after his passing.

Tot is not the only ghost though that has been seen at the Chancellor place. Long ago, several of the workers at the farm claimed to have seen Patsy's teenage brother after he died. At different times, they each saw him walking across the very same road that Tot was seen on after his death. The workers described seeing the ghost of the young boy dressed in overalls. Another worker talked about seeing his deceased wife on the farm on several occasions as well. One time she even rode in the buggy alongside him, The Chancellor farm has proven itself to be quite a magical place with a long history of ghostly

encounters. If you are fortunate enough to ever be invited to visit, sit a spell on the back porch and perhaps you too just might hear the faint call of "Woooo Pat!" coming from Tot's cabin or see one of the three spirits that have been known to haunt its acres.

THE KLEIN WALLACE HOME

The Klein Wallace House immediately grabs the imagination when driving past it on Highway 25 between Harpersville and Wilsonville. The weathered clapboard exterior of the two-story home says that this place has seen more than a century of history unfold at the steps of its Greek Revival portico. Old-timers tell stories of their ancestors picking cotton in the fields at this plantation. Located at the junction of Coosa Valley and the old Kymulga roads, the home would have witnessed Indians traveling by and soldiers, too. Stagecoaches, wagon trains and others going about their business on horseback would have passed by here many years ago as well.

Built in 1841 by Samuel Wallace, the home has stood the test of time. The land was obtained through grants signed by Presidents Monroe, Van Buren and Andrew Jackson. The original rocks gathered from around the home site all those years ago still hold the home up today. Marble from the Sylacauga quarry was fashioned into fancy front steps for the porch. The interior walls were plastered with a mixture of horse hair, reeds from the creek and mud. Samuel built up a large plantation with many slaves and operated a sawmill. There was even once a post office located here. When the family filled out the application to have a post office installed, they had to list three names for consideration. The third name, Klein, was chosen by the postmaster. That is how the name Klein came to be associated with the plantation, since undoubtedly the name Wallace was already taken. Across Highway 25 is the family cemetery and the remnants of a blacksmith shop.

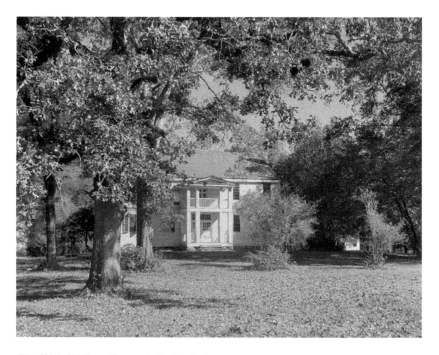

The Klein Wallace House. *Author's collection.*

After Samuel retired and passed on, his son, Wales, took over the daily operations of the farm. When duty called during the Civil War, he left for several years but returned. His wife and more than one hundred slaves kept the plantation going in his absence. Records indicate that the Wallaces were good people and kind to their slaves. More often than not, the doctor would be paid to see the slaves before he would be paid to see one of their own family members. Wales's wife, Kate, established a school on the property for all the children, black and white. She taught her own children side by side with the black children, which would have been very progressive for the times. Many people remember the home as a wonderful place to grow up and visit for parties.

Henry B. Walthall, a silent film actor who appeared in the Oscar-winning film *The Birth of a Nation* as "the little colonel," was born in

1878 and raised in this home. While growing up in Harpersville, he attended school at Elm Hill Academy, which was a different school than the one that Kate Wallace started on the plantation. Elm Hill Academy was known for its fine arts and high degree of culture for the time. This is where Henry discovered his passion for acting. He enjoyed putting on plays at the school and was instrumental in bringing open-air Shakespearean plays to the small town. He moved to New York to pursue a career in acting in the early 1900s. He had a very productive career, appearing in 326 films and shorts. Henry was even awarded a star on the Hollywood Walk of Fame in 1960. During the height of his career, he never forgot his roots or his hometown. He was known for bringing movie stars back to the Wallace home for retreats in between filming. It is rumored that Clara Bow and Rudolph Valentino were some of the famous guests who sipped mint juleps under the grand oak trees.

All is not what it seems at the Klein Wallace Plantation today, though.

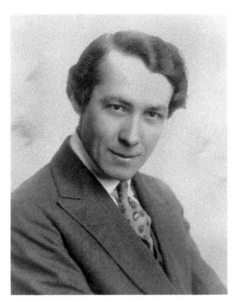

Somehow a dark legend has become entangled with this beautiful old home. People say that during the Civil War, an elderly woman lived with the Wallaces, perhaps Kate's mother since the elder Mrs. Wallace had passed away in 1860. The family got word that Union troops were nearing their home and perhaps had intentions to burn it down. They had no choice but to take a few belongings and leave, but the elderly woman, bedridden, either refused to go or was unable to follow

Henry B. Walthall, a famous silent film actor and Harpersville native. *Courtesy of the Shelby County Historical Society, Inc.*

Kate. She was left with a shotgun by her side. Kate and the rest of the family sought shelter at a nearby Confederate fort where the E.C. Gaston steam plant now stands. When the Union troops burst through the door of the Wallace home, they were met with shotgun fire. The elderly woman was able to take down several soldiers before she herself was killed.

The home is now reportedly haunted by the spirits of the woman and the soldiers she killed. Their restless spirits reenact the events that took place on that fateful day. Whispering voices and strange occurrences have been noted by more than a few people. Another legend says that a doctor lived in the home once and treated patients upstairs. A few of his patients died, and he believed that they were haunting the upstairs and his attic. His servants were afraid of going upstairs, and that may have been what the doctor wanted. At least one person believes that the doctor had hidden his silverware in the attic and thought his servants would steal from him if they found it.

Harpersville's own mayor, Theo Perkins, seems to have crossed paths with a ghost there one day. He was taking a group of people on a historical tour and left his keys inside his unlocked car. When he returned, the car had been mysteriously locked. Rumors about town say that the last family that actually lived in the home had to move out in the 1950s because ghostly whispering voices drove the mother insane. No one has attempted to live in the home since.

OLD BAKER FARM

When the price of cotton and the textile industry turned volatile some years ago, Pam and Jerry Baker were faced with a difficult decision. It looked as if they may have to sell the farm that had been in the Baker family since 1899. They did some soul searching and "a lot of prayin'," says Jerry, but they decided to open up their farm to the public and change their business model. They now grow and sell

Christmas trees and several varieties of pumpkins and have summer programs for children in daycare. In the fall, it is not uncommon for fifty thousand pumpkins to be harvested. The farm has now been worked by the Baker family for over one hundred years. It was one of only twelve farms chosen for the USDA 2000 calendar entitled "Millennium Celebration of Century Farms."

The oldest homestead in Shelby County, the home on the farm was already one hundred years old when William and Martha Baker purchased the farm in 1899. They were forced to leave their home in Cherokee County after iron foundries had ruined the soil and cotton no longer grew on their farm there. They got word from a relative that a farm in Harpersville was for sale, and they took a chance on it. William and his boys traveled by wagon with most of their belongings while Martha and the younger children took a train.

The barn that stands there today was built in 1919 out of heart pine cut at a mule-powered sawmill. Pam and Jerry credit the wood selection with how well it has stood the test of time. The only change that had to be made was the roofing. Jerry's father, Earl "Papa" Baker, had the original wood shingles replaced with tin shingles on both the barn and the house after having to send his boys up to the roof with buckets of water too many times to dowse flames caused by embers from the wood-burning stove.

A half-mile trench runs between the Old Baker Farm and the farm next door where present-day Morgan Creek Winery sits. Historians believe it was dug out by the Confederates in anticipation of Union troops marching into Harpersville. They have found five in all in the area, one other being on the grounds at E.C. Gaston Steam Plant in nearby Wilsonville where a fort once stood. When Union troops left Memphis and headed toward Alabama, people in Harpersville were very frightened. They gathered at the fort near where the steam plant is today in anticipation of the worst. The Union troops went farther west than everyone anticipated, though, as they marched onto Shelby Iron Works and Brierfield. The Old Baker Farm was saved that day, as were many of the wonderful historic places in the town.

Certainly with as much history as the farm has, there would be a ghost or two that has taken up residence at the farm, but Pam and Jerry haven't ever seen one. They do have a couple legends, though, and even a story of a miracle.

The Legend of the Gold

Before the Bakers came to Harpersville and when Indians were still known to hunt the area, a stagecoach was attacked by a band of Indians near present-day Highway 25. Legend says that gold bricks were stolen from the stagecoach and buried in the vicinity of the Old Baker Farm. Sadly, no gold has ever been found on the farm.

Young Earl Baker's Miracle

The smallest boy of fourteen children, little Earl Baker only had one toy his entire childhood. It was a brown rubber ball that went with him everywhere. He took very good care not to lose it. He spent many hours playing with it on the farm. Everyone knew how important it was, but one day when little Earl was about six years old, big brother Lester thought it would be funny to tease him and took a big stick and hit that ball way off into the cotton fields. Earl ran after it but could not find it. He looked and looked until there was no more sunlight. The next morning, he went out with his mom to milk the cows before breakfast and asked her if he could go looking in the cotton one more time. She agreed to let him go, and he ran out to the spot where he thought it should be. Again, there was no ball in sight. With a heavy heart, he looked toward heaven and said so innocently, "Please God, help me find my ball." When he looked back down, the ball was right there at his feet.

The Legend of Earl Baker and His Dog

People say that Earl Baker was a legend of sorts himself. He bought the Baker farm from his father when he overheard him say that he was selling it to someone else the next day. Earl did not want that to happen, so he asked his father if he would sell the place to him instead. Earl had saved almost all of his earnings from working at the munitions plant in Childersburg and had earned a little interest on it over time at the bank. It was enough to pay his father cash, and he never went into debt to buy the farm or anything else his whole life. He was described as a stout, strong man. In all her years of knowing him, Pam Baker said she never saw him mad. He was tender-hearted but a hard worker. In his younger years, he was the farm's blacksmith and had worn out the anvil by the time he reached 21. Toward the end of his life, he had a good loyal farm dog that stayed by his side. When Papa Baker died at the age of 101 years old, they found that dog dead the next morning lying outside his bedroom window. The two friends undoubtedly made their final journey home side by side.

THE BLACK CAT BONE

Shawn Baker has lived his entire life in the small town of Harpersville, Alabama, except for the four years of college he attended at Montevallo University. His family grew cotton on their farm and over the years had many tenants who leased farmland from them. Shawn, a lover of history, got to know several of the older tenants and enjoyed spending time listening to their stories of World War II, the Negro Baseball League and days gone by. When it was time for Shawn to leave the safety of the farm and head to college, he got a mysterious phone call from one of the tenants, Mr. Smith. He

wanted to give something to Shawn before he left and asked him to come over after dark.

When Shawn arrived at Mr. Smith's house, a large black kettle boiling with a crackling fire beneath it was in the front yard. He could see by the full moon light that Mr. Smith was sitting in a chair on the front porch waiting for him with a cat in his lap. He was stroking the cat's black fur. Shawn approached Mr. Smith, and he explained to Shawn that he wanted to give him a black cat bone for good luck and to keep him safe. Not really sure what Mr. Smith meant by that, the naïve boy went along. "How do you make a black cat bone?" he asked. Before he knew what was going on, Mr. Smith had thrown that cat into the kettle, put the lid back on and said, "You gots to boil it first." Shawn's eyes grew big at what he had just seen. That kettle lid kicked up once, maybe twice, but that cat's nine lives were over lickety-split. He knew his friend was sincere in his beliefs that this would help protect him and that the ritual was important to him. He had been around the old farmworkers long enough to know that not just anyone is allowed to witness these rituals and only certain people in the community were allowed to perform them. Over the years, he had been privileged to watch several other voodoo ceremonies, but many of the people have sworn him to secrecy.

For several hours, they sat on the porch and talked while they waited for the cat to be ready. Mr. Smith told stories as usual to pass the time. Finally he jumped up and said it was done. They strained the water, and the meat fell off the bones. Shawn was instructed to put the bones back together in the shape of a cat and to place them on top of Mr. Smith's roof where they could dry in the full moonlight. He said he would call Shawn when it was ready.

About a month passed, and Mr. Smith called as he had promised to come get the bones off the roof. They placed them all in a burlap sack and went down to the old wash rock at the creek. Mr. Smith gave very specific instructions to Shawn. He told him to throw them all in the creek and watch carefully. One bone will go upstream while the rest go downstream. He said to grab the one bone that goes upstream,

but only if it is not the cat's head. If it is the cat's head, it will bring bad luck because the cat's eye will always be watching you. Shawn tried to remember what to do as he emptied the sack of bones into the creek. To his amazement, the bones did just as Mr. Smith said. All but one went downstream. "Get it! Get it!" Mr. Smith shouted as he jumped up and down in excitement. Shawn quickly scooped it up, and Mr. Smith said with a smile and a nod, "Now, that's your black cat bone." He told Shawn to never lose it and it would always help him. He has wondered if the old black cat bone has indeed worked some magic from time to time. It has been over twenty years, and he still has his good luck charm today.

PART IV

SHELBY

SHELBY HOTEL

Sitting next to Shelby Iron Works Park on Highway 42, the slowly decaying Shelby Hotel barely clings to life. A white picket fence once surrounded the two-story structure that has tall windows to let in ample sunlight. Double chimneys balance the roofline in the front that comes to a point in the middle. A covered porch with round columns probably once held a swing and a few rocking chairs for guests to enjoy. "No Trespassing" signs now replace the welcoming sign that once stood out front proudly stating, "Alabama's Oldest." Despite its outward appearance, Shelby Hotel is indeed a historical treasure. It was the first in the state to have both running water and electric lights. Imagine that! It was located in the center of one of the county's busiest industrial areas. A railway located just behind the house brought in hungry customers and weary travelers from 1863 until it closed sometime after the mines shut down in 1922.

The original structure that was built here burned down in January 1898. It was run by Mr. and Mrs. Wade back then. It had thirty

rooms and was called the Dannemora Hotel. No one died in the fire, thankfully, and there was only one injury caused by a falling chimney that struck a man named Thomas Bierly on the head. It was reopened two years later and had fewer rooms than before. It was still the place for Shelby's most prominent people to hold their social functions. Newspaper articles listed the who's who in attendance at parties here and also state that the town of Shelby had its own orchestra that played for guests. A birthday party for a thirteen-year-old girl written about in the *People's Advocate* in January 1912 describes a night of hot chocolate, boxes of candy and games until a late hour. The hotel continued to be an important part of the community for many, many years. Ownership of the hotel changed hands, and eventually the Rummels made Shelby Hotel their own.

According to Mr. Rummel, there was no better cook in the state than his wife. People would pile off the trains all day long, and she kept them fed. She was a true southern lady and a gracious host. She managed the staff and made sure every one of the eighteen rooms was in tip-top shape. Undoubtedly, Mrs. Rummel was just as much a key to the hotel's success as its location next to big industry. It even had a special honeymoon suite with a tall, shiny black wooden bed with white linens. Many Alabama newlyweds spent their first night in their hotel, and that was something the Rummels were proud of. They were especially delighted to host Teddy Roosevelt for an evening in their fine establishment. Years later, when another Roosevelt was running for president, his opponent, Alfred Landon, and his family spent the night at Shelby Hotel as well. There is also a legend that inside one of the rooms, a bullet hole remains in the wall to this day from an assassination attempt on the life of one of their visitors. My brother-in-law, Danny Foster, grew up in the area. As teenagers, he and a few friends snuck into the hotel one night looking for ghosts many years ago after the building had been abandoned. They saw the bullet hole firsthand, but no one seems to know the story behind how the bullet hole got there. Since no harm was done and no life was lost, perhaps the Rummels just decided

to keep it a secret, and their guest might have wanted it that way as well.

Many distinguished—and some downright shady—guests have come and gone from Shelby Hotel, but it seems that one person who holds the place dear in her heart has remained. The spirit of Mrs. Rummel can still be felt and sometimes heard inside the dying building. A woman, who wishes to remain anonymous, tells the story of how she stopped by to admire the old hotel one evening just before sunset many years ago. She had passed by several times and had always felt drawn to the place.

This particular evening, she pulled over and gave in to her curiosity. She saw a glimmer of something in one of the windows that caught her attention, so she walked a little closer. She admired the old planks of wood with the paint peeling off and thought maybe she should just go close enough to peer inside. A broken window allowed her to see in one of the rooms and smell the old, abandoned-building smell. She stood there for a moment taking it all in. She imagined the days of the smoking furnace next door and the screeching train wheels coming to a halt that would alert the hotel staff to impending visitors. All of a sudden, it felt like something or someone walked into the room where she was peering in through the window. She nervously said, "Hello?" but to her relief, there was no response. Still, she could not shake the feeling that someone was standing there. She walked around the hotel grounds outside and appreciated its charm a bit more before leaving. Before she departed, she went back to the broken window one more time. Feeling a bit silly, the woman said out loud, "Goodbye now. Is it OK if I come back sometime?" Much to her surprise, she heard a sweet woman's voice say back, "Yeah, sure!" Perhaps Mrs. Rummel is indeed still cooking the meals and minding the staff in the run-down building. Maybe her dedication keeps her going even to this day. Although the train tracks are no longer behind the hotel, I wonder if the train still stops there on some nights unloading cars full of ghostly visitors for Mrs. Rummel to feed.

OLD SHELBY CEMETERY

Located near the intersection of County Roads 47 and 42 just outside of Columbiana sits one of Shelby County's oldest cemeteries. On the surface, this cemetery looks quite serene and has a large, beautiful oak tree in the center offering shelter to many of its residents. The first burial here took place in 1885—a time when passenger trains made as many as eight stops a day at the nearby Shelby Hotel. Many of the first burials were children—a sad reminder of how hard life was before modern medicine.

I had passed by this particular cemetery on numerous occasions on my way to visit a good friend. I would have never known it existed if it had not been for an acquaintance of mine who pulled me aside one afternoon to tell me of several experiences that he and his family had at Old Shelby. Being an avid genealogy researcher, my acquaintance (who wishes to remain anonymous) frequents many of the local cemeteries. Old Shelby, however, was one that made my acquaintance feel quite uneasy. His first experience took place one afternoon when he visited the cemetery all alone. He was casually walking the grounds jotting down names and dates for his research when he realized that he felt like someone was watching him. His anxiety started to build, but he tried to push it out of his mind and pass it off as nothing. That little thought just would not leave him alone, though. He turned to look over his shoulder just to check, and when he turned back around, the ghost that had been quietly stalking him through the graveyard rushed past him with a great force. Quite surprised but not deterred, my acquaintance finished his work, albeit a little hastier than usual that day.

Having found some interesting grave sites at Old Shelby Cemetery, my friend returned not long after with his parents in order to show them. Although he was wary of the old graveyard, he did not think any harm would actually come to him or his parents. Perhaps he should have considered the first ghostly experience a warning, but nothing could have prepared him for what was about to happen. As

Old Shelby Cemetery. *Author's collection.*

his elderly mother walked toward the graves that he wanted to show her, the ground beneath her collapsed and she fell into a grave up to her waist. Her son quickly helped her out. Although everyone was shaken, his mom was thankfully not hurt. As if this experience was not bad enough, the ghost was not done harassing them yet. When they tried to leave, their car's back-up sensors kept indicating that something was standing directly behind the vehicle. They got out to double-check, but nothing was there. Others have reported being grabbed on the back of the neck and seeing a tall shadow figure pass by the front entrance. If you are brave enough to venture to Old Shelby Cemetery, take caution that you, too, do not fall victim to a caved-in grave.

CHELSEA

THE DEVIL'S CORRIDOR

Down Highway 32, also called Pumpkin Swamp Road, new homes and subdivisions are mixed with the old. The road is curvy and wooded. The path of the road probably has not changed much since the times of horse-drawn buggies. The first families here were the Weldons and the Waltons. There actually was a post office down Shaw Lane just off of 32 in the late 1800s, but no sign of it exists today. The town was named Weldon after the first family that settled here. Before that, there were Creek Indians. Pumpkin Swamp was one of the few documented areas in Shelby County to have Indian settlements when the first white settlers arrived. At one end of Highway 32 is the old Union Church that hints at how long the community has been around. At the other end is Highway 49. From end to end, there have been stories of strange sightings and devilish deeds.

In the Union Cemetery, the graves go back as early as 1878, and it is still used today. The church has been renamed the Church at Chelsea

Park and has added a new sanctuary in recent years. It was here one morning, just before dawn, that one eyewitness saw a black mass floating in the air near the fence of the graveyard at the intersection of Highway 51. Farther down the road, people have reported the inexplicable sounds of children playing in their homes. When one woman went to tell her children to stop playing and go to bed, she found them all fast asleep. Another woman even reported feeling a small, child-sized hand tap her in the middle of the night, waking her up. The landscape is dotted with old family cemeteries along this road, two in particular belonging to the Walton family. Several children are buried in these plots, according to records. Could it be the children of the farmers who plowed the land long ago that now haunt the new homes? Perhaps there were also sharecroppers who worked the land or slaves and their families.

Children are not the only ghosts that seem to be making their presence known in this area. Shadowy figures in the shape of dogs and cats have also been seen trotting through homes. One man even reported being growled at one night. He was so frightened to get out of bed that he summoned his wife from another room to come to the bedroom to turn the lights on. His reaction troubled his wife so much that she was convinced a wild animal had somehow gotten into their house. The two sat in the bed, afraid to look, for certainly there was a wild beast under there. At last, the wife was the one to find the courage to take a gander, but she found nothing at all under the bed or in the home that resembled a wild, growling beast. The couple would have likely found a reason to dismiss it, given enough time, but the very next morning, their oldest son, a boy about eight years old, was wide awake early and claimed to have seen the ghost of a black dog walk through the living room into the parents' bedroom just moments before. The boy had no knowledge of what had happened the night before as he was asleep by the time it happened.

For years the people of this area have experienced bizarre happenings. Newer residents to the area may not know, but years ago, just before the intersection with Highway 49, a little shack sat off the

road to the right. It was the home of a recluse who was never seen during the day. The shack was probably only big enough for a living room, kitchen and bedroom. The exterior was not painted, which left the grey, weathered wood exposed to the elements. A rusted tin roof sat on top to complete the look. A homemade sign was posted by the road with the words "Devil's Den" scrawled out in black paint. Rumors spread around town about who this man was and what he was up to in that shack.

Undoubtedly, it was quite the eyesore as well to drive by and see the sign by the road—especially in a place that prided itself on Christian values. When the man died, it was probably a relief when they started tearing down the house. The sign was the first thing to go. People had speculated for years what they might find, but no one was expecting there to be hundreds of pots filled with the bones of animals filling up the shack. People spread rumors that he might have been performing satanic rituals all those years and those bones were his animal sacrifices. Speculation about the man's religious affiliation aside, I am inclined to think that the numerous animal ghost sightings in the area are related to all those bones. If, heaven forbid, the man actually had been practicing satanic rituals in the shack, then that could be the reason for almost all of the reported activity along the road. Perhaps he opened a portal, and that is why the road has now become the Devil's Corridor.

THE YELLOW LEAF CREEK TRAIL

As I drive down Highway 49 with local historian and longtime Chelsea resident Tracy Jones, she points out various homes of interest. A house on one side of the road was the site of a murder-suicide, while in another one, a freak house fire claimed the life of the owner. One man's wife died of an aneurysm, and they found him dead in the front yard a few days later. We've only gone a mile or

two at most, and the list of tragedies continues to grow. We come to a bridge, and she tells me the story of a senseless man who pushed his pregnant girlfriend out of a speeding van at this spot. Both the woman and the baby died. Not far from here, a family was forced to leave their home after paranormal activity drove the mother almost insane. We near the road that Tracy used to live on for twenty years. Just before we turn onto that road, Ivy Way, she points out to me the mound of dirt at the entrance where her best friend was involved in a mysterious single-car accident that took her life. Believe it or not, these were not all of the tragic stories that Tracy shared with me that afternoon. She had her own personal story to tell as well.

Tracy lived on Ivy Way from 1975 until the early 2000s. She and her two brothers were raised from birth in their modest home at the end of the lane on the right. She is visibly shaken to even drive by, although the home no longer stands today. The whole family endured an array of paranormal activity that has taken an emotional toll on all of them. Tracy believes that it almost took her father's life as well.

Her family experienced many shadow people around the house. Sometimes they would be woken up at two or three o'clock in the morning by the foul smell of death lingering above them. Tracy's brother Todd even woke up to his pillow hovering above his face one night. Her other brother Dennis tells the story of having his bed shake while he was trying to sleep and seeing a full-bodied apparition standing at the foot. They had bad luck with pets, too. They often got sick, and some died. Even Tracy's visit to Ivy Way that day for our interview seemed to have an ill effect on her dog. When she got home that evening, the dog fell ill and passed away the next day. It was the first time she had been back to Ivy Way in nearly ten years, and it still seemed to have a grip on her.

Tracy's grandmother had Alzheimer's and lived in a house on Ivy Way for a time as well. Tracy would spend the night with her to make sure she was OK. One night while she was there, she had a frightening dream that a man was barreling out of one of the bedrooms of the home with a large knife and was coming right for her. Just as Tracy

startled herself awake from the dream, her grandmother woke up screaming, "He is trying to kill you, Tracy!" She said the man she saw in her dream wore a coat from the nineteenth century and was very tall. He was definitely a white man. The full-bodied apparition her brother saw shaking his bed was also that of a white man. While there is some history of natives hunting in the area, they never saw an apparition that looked Indian. While also in her grandmother's house, they all once heard something rather heavy being dragged across the roof of the home. When they ran outside to investigate, nothing was there.

Tracy also had strange, reoccurring dreams about the Confederate cavalry. One day when they were playing in their backyard, they dug up a minié ball like the Confederates used during the Civil War. Could this be related to the apparitions and dreams? The family found their cast-iron skillet inexplicably bent in half one morning after a night of paranormal activity in the home. No man is strong enough to perform such a feat with his bare hands. How could this have happened? They set it aside and pulled out another to prepare their meal. The next day, to their complete amazement, the bent skillet had been laid flat again, good as new.

A new tape recorder brought much excitement for Tracy and her siblings when they were kids. She could not wait to try it out by recording some songs from the radio. Music was one of the little things that helped all the kids cope with the chaos that went on in their home sometimes. It was one of the few comforts they had besides a close bond with one another. Her tape recorder was the kind that most of us who grew up in the 1980s had where we could record from the radio but that was all. There was no external microphone for recording our own voices or anything else. She recorded several songs from a radio station one day but her favorite, Louis Armstrong's song "What a Wonderful World," was the one she couldn't wait to hear. When it played, she was startled by the loud voice of a man growling, "Get out!" and then another one pleading, "Let them go!" followed by a cat's meow. How did this get recorded

over her song? She and her brothers were shaken to their cores. Even the simplest of life's pleasures had been stolen from them by these spirits. Over the years, the voices did not stop. The family received many enigmatic voicemails left on their answering machine from the whispering phantoms.

The harassment continued to intensify toward the end of their time in the home. After twenty years of enduring it, Tracy's dad could take it no longer. It had taken a toll on all of them, but for him, the toll was a physical one. Tracy's dad was rushed to the hospital with a heart attack when he was only forty-one. He was the spiritual center of the family. He was the one who held them together when things got the worst in their home. The family made the decision to leave and to only take what they could carry from the home in as few trips as possible. They moved out in a hurry before any more harm could be done to them by the malicious spirits.

Digging into the history of the area near Ivy Way, there was an old mustering ground nearby at a spring. This could explain the minié ball that was found. Also, the Yellow Leaf Creek passes right through the land, which was a trail people followed in the old days. It leads all the way to the Coosa River. It is known that the bands of ruthless deserters who caused so much trouble for the home guard during the Civil War haunted Lower Yellow Leaf around present-day Chilton County as well. Could they have followed the creek up this far looking for fresh supplies? History tells us that Indians, explorers, traders, trappers and settlers would have all passed by the land that is Ivy Way and Highway 49 since it is so very near a major intersection that would have taken early travelers to and from Mississippi. Those journeys would have been difficult and perilous if facing unfriendly natives or roving bands of misfits. Several historians have also pointed out that the Chelsea area has always been moonshining territory. Even today, people find old stills in the creek bottoms on their lands from days gone by. Chelsea has a seedy past. Parents warned their children not to wander into that part of the county. It was definitely not a place to get caught in after dark.

My guess is that you could pick any one of these scenarios, and it probably plays out with a cast of ghostly characters on any given night down these roads that are steeped in so much history. I only hope that their restless souls will soon find peace as they are seemingly taking quite a terrifying toll on the small community along the Yellow Leaf Creek Trail.

CHELSEA'S URBAN LEGENDS

The Crenshaw Vampire

Down Crenshaw Road, there exists a legend of a vampire. The road is dirt, and the woods are thick. Part of the land belongs to a hunting club. On the east side of the small wooden bridge that crosses the Yellow Leaf Creek, a few homes can be found, but they are spread out and few in number. On the west side of the bridge exists the hunting lands. The creek and woods are quite lovely on a sunny afternoon. Arrowheads can be found by the handfuls on the banks. By night, this spot favored by those seeking the seclusion for a lover's lane has turned into a nightmare for many local teens.

Those who have seen the vampire all report the same ugly man with a long white face peering at them through their car window. They say he is very tall, perhaps six foot five, and has unusually long arms. His hair is black as the night, and his skin seems to glow. People who have fled from the vampire say that he cannot cross the creek and he only haunts the east side of Crenshaw Road. He has earned the title of vampire because people in the area have found animals completely exsanguinated with no other visible signs of trauma or cause of death. If you dare to venture out that way at night, be sure to make it over the bridge in time before the long arms of the vampire can pull you back.

The Hippie Hitchhiker

Highway 47, also known as Chelsea Road, is a well-traveled pathway to and from Columbiana. It starts in the heart of Chelsea by the old Weldon Store and continues for miles past Columbiana until you reach the Chilton County line. There are parks, new homes and even a country club located off this road in Chelsea, which is a young but thriving community. Despite this, old farmhouses with rusted, falling-in roofs can still be seen today as a reminder of the early settlers who lived here. It has been a major part of Shelby County's history for more than a century.

Near the intersection of Highway 49, there is a legend of a hippie woman walking the road late at night. Some say she tries to hitch a ride, but when they pull over to pick her up, she disappears. Others have actually seen her in the middle of the road just before they have seemingly run over her. People stop their cars in a panic, thinking that they have just seriously injured someone, only to find no one at all. They all describe the same hippie-looking lady with long dark hair wearing a flannel shirt and jeans. One eyewitness said her whole family saw the woman around 3:00 a.m. after a Christmas Eve gathering at a relative's house. They were on their way back home, and when they neared the intersection of 47 and 49, they saw a small-framed woman staggering along the road in a flannel shirt and jeans. Something did not feel right because as they passed, she did not even raise her head. They immediately turned the car around to check on the woman, but she had vanished that fast.

PART VI

LEEDS

The Ghost of John Henry

John Henry went down that railroad track
With his twelve-pound hammer by his side
Went down the track, but he never looked back
Because he laid down his hammer, and he died
Yes, he laid down his hammer, and he died

Most people are familiar with the legend of John Henry the Steel-Driving Man. We grew up reading the children's books or watched one of the cartoons about the great race he won against a steam drill in the 1800s. John Henry is a hero to the working man, but you may be surprised to learn that his story is not just a tall tale, the likes of Paul Bunyan. There is a good case that John Henry was a real person and his story actually took place. Big Bend Tunnel in West Virginia has claimed the story for decades, but there is strong evidence that suggests the great race took place between the Oak and Coosa Tunnels in Shelby County near Leeds. Old-timers who live

John Henry. *Courtesy of Melissa Jones Art.*

along that mountain where the race took place all tell a similar story that claims John Henry died there that historic day.

John Garst has spent a considerable amount of time analyzing the research previously conducted by Guy Johnson and Louis Chappell, who published books in the early 1900s on the subject. They both decided, despite not having definitive evidence, that Big Bend Tunnel was the location where the big race took place. More people have testified that it could not have happened at Big Bend than have testified that they actually saw it take place there. Only one eyewitness ever gave a statement, and it was weak testimony. Most literature that has been written on John Henry and the great race has been based on the two books written by Johnson and Chappell. Garst is one of the few people to actually challenge their decision and reexamine the evidence.

Three letters were received by Johnson from C.C. Spencer, F.P. Barker and Glendora Cummings. Each of them placed the race in Alabama in the 1880s. Cummings said it was the year 1887, and it was at Oak Mountain Tunnel. Her uncle had witnessed the race. Barker said that John Henry was driving steel at "Cursey Mountain." Spencer's letter gave much more detail but mentioned a "Cruzee Mountain," which sounded like Barker's "Cursey Mountain." Johnson could not find evidence that a mountain by that name existed, so he abandoned the Alabama story altogether in favor of Big Bend.

Some interesting details in Spencer's letter said that he personally saw John Henry perish on that fateful day. It was September 20. Undoubtedly, it would have been still quite warm and humid, as Alabama residents know that summer still lingers in the South well into late September. The trees would have been cut down to allow access for the men to work up on the rock. The sun would have been glaring down on him during the all-day contest against the steam drill. Spencer said that John Henry "fell into a faint" near the end. He regained consciousness but was blind and dying. He asked for his wife. She came and sat by his side, holding his head in her lap. He wanted to know if he had beaten the steam drill, and indeed he had.

Spencer said the measurements were twenty-seven and a half feet for John and twenty-one feet for the drill.

Some more details that Spencer gave connected John Henry to the Dabney family of Holly Springs, Mississippi, where he was possibly a slave before the emancipation. Captain Frederick Dabney was chief engineer for the Columbus and Western Railway Company during the construction of its line between Goodwater, Alabama, and Birmingham in 1887–88. Just outside of Leeds, before you get to Birmingham, sit two tunnels that would have been a part of the C&W construction. One of those tunnels is the Coosa Mountain, and the other is Oak Mountain. The tunnels are two miles apart. According to some older documents, Coosa used to be spelled Koo'see and pronounced the same way. Perhaps this is the same "Cruzee" and "Cursey" Mountain that Johnson was looking for all those years ago. In addition, in at least a dozen versions of the ballad of John Henry, there are lyrics that suggest the location was in Alabama or mentioned "the Georgia Line" referring to the Columbus and Western Railway or C&W.

The local tradition in Leeds claims that John Henry raced the steam drill and died just outside the east portal of the Oak Mountain Tunnel in between the two tunnels. This is a legend that is as old as the story of John Henry himself. In the Leeds Historic Southern Railway Depot Museum, there is a picture of a gold spike that was drilled into the rock supposedly by John Henry himself at Oak Mountain Tunnel on the day of the big race. It remained there in the rock until just recently, when it mysteriously vanished. No signs of drilling or other use of force on the rock to pry it out were present surrounding where the spike had been. It is not the first mysterious thing to happen at the tunnel since John Henry died all those years ago.

Engineers describe feeling uneasy or being watched when they pass through the Oak Mountain Tunnel. People who venture there agree that it has a very eerie feel to it for sure. Undoubtedly, the danger of being trapped on the tracks by a train and surrounded by solid rock may have something to do with that feeling. Stories of John Henry haunting the tunnel have existed for years. There

Above: The Oak Tunnel Sign. *Author's collection.*

Below: Oak Tunnel, where John Henry reportedly died. *Author's collection.*

is even a legend that a train overturned once near the tunnel and a creature with white fur escaped. Locals dubbed it "the Dunnavant White Thing." People used to say, "Don't go down to the tunnel, or the Dunnavant White Thing will get you!" Of course, this could just be parents trying to scare their kids away from the perilous rocky walls that are certain to lock you into a death trap if a train were to

catch you off-guard. I will take the engineers' word for it that ol' John Henry's spirit still haunts the darkness of the Oak Mountain Tunnel and not risk becoming another ghost for locals to speak of when mentioning the tunnel.

SICARD HOLLOW ROAD

Just off Interstate 459 lies a road that winds alongside the Cahaba River. Sicard Hollow Road is known as a place for nature lovers to go and unwind for a while. On any given day, a canoe or two can be seen making its way slowly down the river. Children and fishermen gather along the banks, and the "share the road" signs are a constant reminder to be on the lookout for the bicycles that are sure to be present.

Underneath this tranquil shroud lies a road with a long-forgotten but shaded past. In the beginning, the land was inhabited by the Creek Indians. The War of 1812 brought Andrew Jackson, who widened the old Indian paths to make room for supply wagons. Several skirmishes between Jackson's troops and the Creek Indians were reported in the area surrounding Sicard Hollow.

During the Civil War, Brigadier General James H. Wilson led a detachment of Union cavalry known as Wilson's Raiders on a path of destruction through Alabama and Georgia, burning and pillaging many now historic sites such as Shelby Iron Works and the University of Alabama in Tuscaloosa. While Wilson's men were marching toward present-day Leeds, the Confederate home guard got wind that Leeds would soon be a target. The home guard went into action and quickly cut down large trees to block the road all along what is now Highway 119 to deter him.

Wilson's men would not be outsmarted. They rerouted down Sicard Hollow Road to gain access to Leeds. One can imagine the state of mind these men must have been in once they realized the

fairly flat road that is 119 was blocked and the only way around was a steep, rocky road through a holler. I wonder if it only made them even more irate by the time they reached Leeds. Or perhaps it worked in the town's favor, and the men were so dog-tired that they only had enough energy to take cattle and belongings, because they refrained from burning the town that day.

The 1920s brought mining and the inherent dangers associated with it to Sicard Hollow. Some have speculated that mining is how the road got its name. Supposedly miners would roll coal cars down the hill toward Sicard Hollow and yell out "See car holler!" and over time, the name just got shortened and changed to what it is today. Leeds town historian Pat Hall believes that the road got its name for a prominent family in the area. There are two documented deaths in Sicard Mine, but there is always a chance there could have been more that we do not know about.

Sicard Hollow Road definitely has an odd and eerie energy to it. There are reports of seeing shadow figures and lights along the road late at night. One particular bend in the road has also been reported to have an uncommonly high number of car breakdowns. They are mostly related to problems with the electrical systems of the vehicles. So if you find yourself driving along Sicard Hollow Road late at night, be careful. It seems that who or whatever is haunting Sicard Hollow doesn't always want their guests to leave.

THE DUNNAVANT VALLEY MYSTERY

On December 2, 1951, the lives of Levi Ann Bragg's family and friends were turned upside down. Levi, a seventy-six-year-old grandmother who had been a teacher and midwife in her younger days, walked down a wooded path off of Brasher Lane from the home she shared with her daughter and son-in-law. She was going to her son's house to visit with her newest grandchild. It

was a well-worn path that she had taken many times before. Her daughter thought nothing of it as she watched her spry, white-haired mother walk away and disappear down a small dip in the trail. Her brother's home was only about one hundred yards away from her house. A small creek ran between the homes in the woods. She never thought it would be the last time she would ever see her sweet mother again.

Levi's daughter, Mildred, did not start to worry about her mom until the evening bus brought her husband home at dusk, and her mom had not returned. Mildred's husband rushed over to her brother's house to check on Levi. His heart sank when Mildred's brother said that his mom had never arrived to his home that day. The family called the police and searched the woods all night. The darkness worked against them, and so did Mother Nature. A hard rain fell, washing away footprints and valuable evidence.

The next morning, a major search was held. It was actually the largest land and air search in the state of Alabama up until that time. Family members, Boy Scout troops and even airplanes circled above the mountain. Word in the small community had spread fast, and hundreds of people were on the mountain searching for the dear grandmother. No trace was ever found, but Levi's son and son-in-law both held out hope. When the hundreds left, they continued to search on. Psychics came from across the country to ask for money in exchange for information about Levi. Some were paid, but no leads were ever generated. The case gained national attention, but still they knew nothing of her fate.

With no answers, things took a turn for the worse. Neighbors accused the family of killing Levi and hiding her body. The police investigated those claims, but Levi's daughter was eight months pregnant at the time and not capable of committing such a crime, even if she had a motive. Her husband was always working, and his time cards at his job proved his innocence. Levi's daughter even told the police they could tear down her house if it just meant they could find her mother.

When it became apparent that Levi was really gone, the family had her declared legally dead. Her daughter Mildred received a small payment from an insurance company and spent every dime of it on a grave marker that the family could visit. Levi's marker is next to her son's, Eddie. He died tragically in a mine explosion on the day of his wedding. He was trying to work overtime to have some money to take his new bride on a honeymoon. Sometimes it is hard to understand why one family must endure so much tragedy. The graves are in Stand Pipe Cemetery in Cahaba Heights.

For over sixty years, there have only been theories and no closure for this family. Some say Levi must have stumbled upon a moonshine operation near the creek in the woods. Others say she was buried in Shady Grove Cemetery off Highway 280 beneath another body. There have even been reports of her ghost wandering about Dunnavant Valley and the area of Highland Lakes. Only one thing is for certain about this story: the pain that this family has felt is unimaginable. Even to this day they seek answers. They will never give up looking for their loved one. If you have any information that may be helpful to this case, please contact the Shelby County Sheriff's Office.

ELVIS AT THE VISITOR CENTER

It was 1955, at the tender age of twenty, when Elvis Presley finally achieved his dream of being a professional singer. The humble boy from Tennessee had worked his way up from being the third or fourth on the billing to headlining in that year. With his mix of country, blues, R&B and pop music, the crowds at his shows quite literally became riots. It was also during this year that Elvis would appear on the bill with Buddy Holly and another legend of the era, James Dean, would lose his life.

Some of Elvis's early hit singles from 1955 were "Baby, Let's Play House" and "I Forgot to Remember to Forget." His charisma, good looks and sense of humor won over the hearts of girls everywhere. He toured mostly in the Southeast, but by the end of 1955, when his career really started taking flight, calls from Hollywood were coming in. Despite his busy schedule, he took time off to take his girlfriend, Dixie Locke, to her junior prom back home in Memphis. Therefore, his missed the performance with the rest of the act on the bill in Birmingham that night. The next night, May 7, he was due to perform in Daytona Beach, Florida—a nearly eight-hundred-mile journey from his home.

Although the precise day is not recorded, perhaps it was May 7 in 1955 that brought him through the small town of Leeds, Alabama, on his way to Daytona to catch up with the rest of his crew. It's a day in Leeds history that many still remember. Elvis stopped in at the visitor center along Parkway Drive and spent some time talking to the staff. They are probably the ones who suggested that he could get a good meal at the local Italian diner, Augie's. A picture of Augie's from the past shows a tongue-in-cheek parking sign in the window that reads "Reserved for Elvis fans. All others will be shook-up." His visit left an indelible impression on the small town that is not used to hosting big stars. Some say that the town must have left an impression on the King himself as well.

Local historian Pat Hall says that more than one person has told her the story of the late-night workers inside the visitor center, which also serves as the chamber of commerce today. The story goes that after Elvis passed away in 1977, a group of painters stayed late trying to finish up their work before the employees arrived the next morning. As they worked into the early hours of the morning, a strange feeling came over them that they were not alone. The workers felt that the presence with them in the room was none other than Elvis. Perhaps the small town had reminded the homesick boy all those years ago of Memphis. The hospitality of the people, the good food and the

soulful energy that comes with being a historic scenic byway of America all could have attracted Elvis to this place.

Of course, the building itself has some interesting history to it that could explain the feeling that the painters felt that night. It once was the home and clinic of the town doctor, E.C. Clayton. It was built in 1938 from locally quarried brownstone. Perhaps it was the spirit of the doctor they felt or one of his patients who met an untimely death inside the former home. Only the painters themselves can explain why they felt the way they did about the spirit they encountered that night inside the visitor center. I guess we will have to give them the benefit of the doubt, for certainly the experience left them all shook up.

PART VII

STERRETT

FIELD OF APPARITIONS

In a beautiful valley surrounded by scenic horse farms on Highway 43 lies a normally peaceful and ordinary pasture. Goats graze happily on plentiful grasses in the shadow of tree-covered mountains. However, once a year this field becomes the gathering place for thousands of people old and young. What brings so many people from all walks of life and from all over the world to this humble piece of land? For the last twenty-five years, the Virgin Mary has been descending from the heavens to bless and deliver spiritual messages to her followers who patiently wait here.

The story began in Medjugorje, Bosnia-Herzegovina, in 1981. Marija Lunetti and five other children from poor families reported having visions of the Virgin Mary. Marija's story is unique in that she has been having almost daily visions ever since. While visiting Birmingham to donate a kidney to her brother in 1988, she had one of her visions in a field now owned by Caritas of Birmingham, a religious organization that specializes in organizing pilgrimages to

Medjugorje and the printing of spiritual periodicals. Caritas offered her a place to stay during the months of recovery she would need after her operation. From there, a friendship was born with Terry Colafrancesco, founder and director of Caritas. Lunetti has been making her own pilgrimages to Birmingham once a year, usually in June or July, and with her come flocks of faithful followers.

Caritas has grown into a multimillion-dollar enterprise over the years. People live at the headquarters across from the Field of Apparitions year-round and work in the publishing division, travel agency or on the farm. From the outside, the beautiful stone building nestled in the woods complete with a bell tower and metal roof may seem like a wonderful place to live and work. But there are those who have been on the inside of Caritas who now criticize what it has become.

A lawsuit filed in 2010 claims that Caritas is a cult and has been brainwashing its members. Accusations of money laundering have also been thrown around by some longtime members who have left the group. Some thirty members in 1999 and 2000 left the complex after having disagreements over how Colafrancesco spent money. He purchased heavy machinery for himself and then asked the families to write checks to him out of their own savings after grueling workdays. Colafrancesco lives in a nice two-story home with his wife and children while the rest of the residents were made to live in mobile homes.

Is the Field of Apparitions just a moneymaking scheme? For those who have traveled to the little valley to see Marija with hopes of catching a glimpse or a blessing of the Virgin Mary herself, it has been worthwhile. It is not hard to find someone willing to share a story of the sense of peace they received by being there and participating in the event. The Catholic Church does not necessarily endorse Marija's visions, but it also does not deter members from making pilgrimages to Caritas either. That being said, if you are one of the faithful, a trip to the Field of Apparitions next year is sure to be a memorable, heartwarming experience.

PART VIII

WILSONVILLE

The Densler House

Just around the corner from Wilsonville's Main Street on Highway 25 sits the 1879 house built for the John Densler family. During that day, Wilsonville was at its height. The first railroad in the county was completed in 1855 here, and thus it became the heart of the county, boasting the largest population at the turn of the century. A busy train depot was known to have as many as six trains a day running from Wilton to Anniston until the 1930s. An agent was kept on duty at the depot until 1954. Strolling through Wilsonville today, it is a stark contrast to its flourishing past. There are more people now buried in the town cemetery along Main Street than are seen going about business on a weekday. People like Andrew and Diane Moore, however, are trying to restore Wilsonville little by little.

Several years ago when the people of Wilsonville saw the old house next door to the historic Densler place get destroyed in order for a church to be built, many of them decided it would not happen again on their watch. When the Densler house went up for auction

in 2000, Andrew and Diane jumped on the chance to buy it without even knowing what kind of shape it was in on the inside. The house had sat locked up and used as storage for thirty-four years prior to the day of the auction when everything was sold—including all of the junk that was stacked almost to the ceiling.

When the dust of the auction had settled, Diane finally got a chance to see the inside of the place she had dreamed of owning for years. The home was in worse shape than she had imagined. Holes in the ceilings and in the floors had allowed feral cats to come and go as well as admit the elements. In the bathroom, black gunk from the ceiling had fallen in so much that it was level with the rim of the bathtub. The home only had two original light fixtures with one bulb each, hinting at the previous owner's frugality. There were some redeeming qualities, though. The original wide-plank hardwood floors were still salvageable, and the old 1800s catalog mirrored fireplace mantels hardly had a scratch. The trim along the walls was of high quality as well and a rare find for the area. Two and

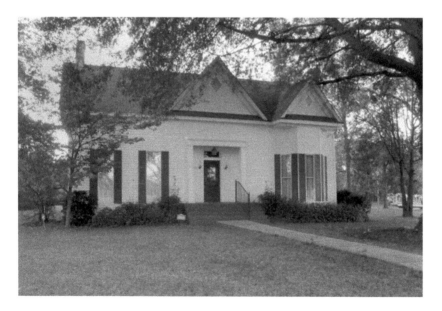

The Densler House as it stands today. *Author's collection.*

a half years of hard work paid off for the Moores. They now have a banquet hall open for business and the Hearts Desire Tea Room inside the beautifully restored home.

Before it was a tearoom, it was the much-loved home of several prominent families in Wilsonville. John Densler owned the local mercantile store and the busy train depot. After John and his wife, Sarah, passed away, it was sold to the Jackson family, who owned the town sawmill, in 1902. One of the Densler daughters, Blossom, married the town doctor, O.E. Black, brother of Supreme Court justice Hugo Black, and bought the home back in 1916. She must have loved the home so much as a child that her fond memories prompted her to buy the place when it went up for sale. She lived there for sixteen happy years until she left for Hollywood with her son. It is said that she and her son both worked in the costuming business.

The Weldon family then lived in the home for thirty-three years between 1932 and 1965. They had several daughters and were known for having regular dances at the home. Mr. Weldon would be instructed to move the furniture out of the way, and the music would play until Mr. Weldon felt it was time for his girls to say goodnight and the boys to scurry home. During World War II, an addition was added to the back of the home by the Weldons to accommodate additional families who worked at the nearby munitions plant in Childersburg. Many families have come to love the little white house on the hill over the years, but there seems to be one man in particular who loved it so much that he has not left.

While the man's identity remains a mystery, we do know from eyewitnesses that he is a tall man. He was even captured in a photo one day on the front porch of the home where a group of ladies visiting the tearoom had gathered to snap a photo. When the photographer looked at the picture, she thought Diane, the only person left inside the house, had been looking out through the glass window on the door. Diane scoffed at the idea. Not only was she not at the door when the picture was taken, but there is no way that she was as tall as the person who could be seen standing there.

The original front door of the Densler House, where the ghost of a man can sometimes be seen. *Author's collection.*

Diane's friend and helper Connie has also seen the ghost of a man in the old house. Diane does not like to admit it, but she has also seen and heard things over the years. The old original mirrors over the mantels face each other across the front hallway, and they play tricks on her eyes. She occasionally sees things zipping by in them. She once kept a baby monitor by the front door in order to hear visitors knocking while she worked in the kitchen at the back of the house. Because she had been surprised by a visitor that she did not hear come in on more than one occasion, she started locking the doors so that would not happen. On numerous occurrences though, she heard footsteps on the hardwood floor coming over the baby monitor as if someone had come in the door. She would rush to the front of the house to see who was there but would find herself all alone and the doors still locked. This happened so many times that it began to be troublesome for her, and the baby monitor was no longer worth the hassle.

PART IX

HELENA

MISCHIEF AT MAGNOLIA SPRINGS MANOR

On a knoll in downtown Helena, located on First Avenue Southwest, sits the stately two-story 1880s home that is now called Magnolia Springs Manor. The man who built the home, C.T. Davidson, was quite an accomplished entrepreneur. He started Helena's first telephone exchange, built the existing Buck Creek Dam and even operated a skating rink, to name just a few of his business ventures. He left his mark on much of Helena, including the beautiful Magnolia Springs Manor, which he built for his brother Nathan Davidson, a merchant, and his wife, Mary. Its current owner, Kathy Hamilton, lives there today with her family but also hosts weddings and receptions at the site, which keeps her very busy. The home is warm and inviting, just like its host. It is the epitome of old southern charm—the perfect place for a true southern bride to have her big day. Like many historic places though, Magnolia Springs Manor has not been immune to tragedy or the occasional ghostly encounter.

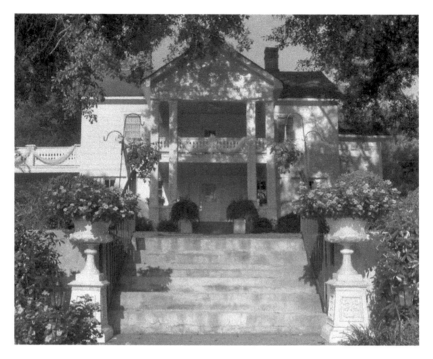

Magnolia Springs Manor. *Courtesy of the Shelby County Historical Society, Inc.*

The first tragedy to hit Magnolia Springs Manor came just two years after Nathan and Mary Davidson moved in. Nathan suddenly died at the age of thirty-six and left Mary a widow with no children of her own. Just two years prior, Mary's sister had died young as well but left behind several children. As was common in those days, Mary then married her sister's widowed husband, Robert M. Tucker. Robert was the town doctor and pharmacist in Helena. Since Mary was most likely already assisting in the rearing of her nieces and nephews, the marriage to Robert made perfect sense. Robert and the children took up residence with Mary in the big beautiful house. He provided financial stability for her, and she tended to the children as if they were her own. Sadly, history would repeat itself years later when Robert's son, Joe L. Tucker, experienced the loss of his young

wife. He was following in his father's footsteps and working as a pharmacist. He gave up that career after his wife's death to become a house painter and decorator. His Aunt Mary took his children in and raised them as well. It has been said that Joe never really recovered from his wife's passing and became a tragic figure of sorts in the small town.

Another couple, Lula and Wiley T. Johnson, owned the home for a decade in the early 1900s. Not much is known about them other than that Wiley once shot and killed a man during a brawl. Surprisingly, Wiley was acquitted when the dead man's wife testified on his behalf. She explained that her husband was the one who started the fight and it was not Wiley's fault. Lula and Wiley lived in Magnolia Springs Manor until he died in 1911 at the home at the age of fifty-six. His wife was forced to sell it a few months later.

In more recent years, tragedy has not visited Magnolia Springs Manor, thankfully. When the current owner, Kathy, purchased the home a few years ago, she did not move her family in right away. She ran her wedding business out of the home though, so she spent a good deal of time there by herself. It did not take long before odd occurrences made her wonder if the house was haunted. The first thing that happened that sent her running out the front door in a fright was her vacuum that kept getting shut off by something or someone in the upstairs room that is used by grooms on their wedding day.

Kathy had successfully vacuumed all the rooms upstairs but this one. Dreading going in the room alone because she always felt a presence in there, she had saved it for last. She plugged in her vacuum and started going about her cleaning when the vacuum suddenly cut off. She checked the power cord and looked at the switch. Nothing seemed to be out of order. She started it back up, and again the power cut off. This time she changed the plug to a different outlet, thinking it could be an electrical issue. The vacuum started right back up, and then a moment later, it stopped again. This time she looked down and saw that the power

The Gentleman's Room used by grooms. *Author's collection.*

switch had curiously been turned off on the vacuum. She flipped the switch, the vacuum came back on and then all of a sudden the lights in the room began to flicker off and on. Kathy exclaimed, "You win! I give up!" and ran from the house.

Another time when she was alone, she decided to go upstairs to watch the only TV in the house at the time while she ate her lunch. As soon as she got to the bottom of the stairs before her ascent, an upstairs bedroom door slammed shut as hard as it could. It was the door to the same bedroom where the vacuum would not work. She froze in fear, not wanting to take another step. Heart pounding, she contemplated what her next move would be, but just then the door creaked back open and slammed shut even harder. There were no drafts from an open window to explain what was happening. She wanted to turn around and leave right at that moment, but her car keys were upstairs. She quickly ran upstairs, got her purse and left.

After Kathy moved in with her family, she also frequently noticed the smell of tobacco despite no one living there being a smoker. Sometimes it was a pipe she smelled, while other times it was cigarettes. She would have brushed this off as nothing, but one day she had an unexpected visitor drop by from New Orleans. The woman, whose name escapes her now, told Kathy that her grandparents had once lived in the home long ago. Her grandfather had died in the home, and the woman remembers attending the wake in the home's parlor, as was customary in those times. She told Kathy that her grandfather had been both a pipe and cigarette smoker. Now Kathy believes the smell of the smoke indicates when this man's spirit is around. After her knee surgery, the spirit stayed by her bedside all day as if he was watching over her. The smell of smoke was so strong that it began to make Kathy feel ill. She told him out loud that he must leave, and he obliged. The tobacco smell left while she recovered but still comes back from time to time.

Apparently, Kathy is not the only person to experience mischief and mayhem at the old home. A groom whose first visit to Magnolia Springs Manor was on the day of his wedding was startled by a shadowy figure appearing in a mirror in the upstairs bedroom that has been known to have strange activity. A previous resident of the home, former Helena police chief Doug Jones, has shared some stories with Kathy as well. He too experienced doors slamming, but what alarmed him the most was when his TV came on by itself one night and his VCR flew off the shelf. It frightened him enough that he called police officers to come to the home and make sure no one was inside the house playing a prank on him.

While we will never know for sure who the spirits in the home are, both Wiley Thomas and Nathan Davidson are possible candidates. Wiley perhaps chooses to stick around because he was a decent, God-fearing man and held onto guilt over the life he took, even though it was in self-defense. Nathan was robbed of a long, happy life in the gorgeous home with his wife. Perhaps

he chose to extend his stay a little longer. The home's upstairs bedrooms were once rented out though, so many people with all kinds of stories have crossed its threshold. The only thing we know for sure is that if you are faint of heart, spending time all alone in this charming southern home just might leave you running for the door.

PART X

ALABASTER

THE BUCK CREEK MILL PHANTOM

Long ago before the bustling town of Alabaster was known by its current name, it was called Siluria. It means "lime," which runs amply throughout parts of Shelby County. On the banks of the Buck Creek, Mr. Thomas Carlisle began a cotton mill and built a small village with sturdy houses for mill employees to live in. It would be a legacy that would last eighty-one years before closing down in 1979. Many of the mill houses still stand today, although the mill itself was condemned some years ago and torn down. The only sign of its existence now is the rusting water tower and small, two-cell brick jailhouse that stands in its shadow. Both are now fenced off to keep mischievous teenagers out after several incidents occurred in which police had to remove people from the top of the tower. The people who worked in the mill long ago tell fond stories of being there and living in the mill village. Those who have gone to the mill area after dark tell a much different story today.

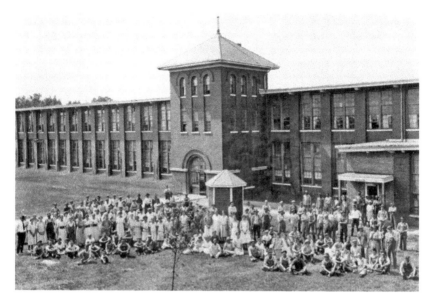

The Buck Creek Mill. *Courtesy of the Shelby County Historical Society, Inc.*

Mr. Thompson wanted to make life in Siluria as happy and pleasant for his workers as possible. He wanted to provide for them in as many ways as he could. There was a doctor who lived in the village, stores, a hotel, a ballpark and a clubhouse. He built churches and a school. There were parks, a movie theater and a recreation building. Classes taught employees how to cook, sew and play instruments. They even had their own band that would play on Sunday afternoons. Sometimes they would even dance in the streets while the band played late into the night on the weekends because it would be too hot inside the recreation building.

Growing up in the mill village did not seem so bad. The mill paid enough to get by, and most families did not worry about where their next meal would come from. During the Depression, mill families didn't suffer like so many others in the area. Rent was only one dollar per room, and almost all their needs were met. In the summertime, boys would soak corncobs overnight in water and have corncob

battles in the streets, getting each other completely drenched. Or they would bend a small sweet gum tree over, have a seat on it and then let it fling. The tree would throw them in the air, providing hours of fun.

Of course, swimming in Buck Creek was the best summer treat the kids had in the mill village. Back then, there were not any regulations, so all the fabric dye from the mill dumped right into the water. After a day of swimming, all the boys and girls would come out colored blue from tip to tail. Halloween was always a fun time in the village as well, and there were sometimes a few tricks to be had in the name of fun. One Halloween night, some of the boys tipped over each and every one of the town's outhouses.

The small jail was rarely used, according to longtime residents of the mill town. Usually if someone had too much to drink, the sheriff would rather drive the person back home than lock them up overnight. The one person I talked to who did confess to spending some time in the old jail was Thaddeus Brooks, and he only stayed there a few hours when he was fourteen. A girl he was dating had convinced him to climb the water tower with her one afternoon. She went up first and teased him for not coming after her, so he decided to go up. The police caught the pair and locked them up and then left. It was several long hours before they returned to release them. Thaddeus thought they intended to keep him there all night but was relieved when he got to go home.

A few people say that Dick Posey spent a night in the old jail once for hitting a woman after she called him a liar, but when I spoke to him about the incident, he said that he only had to pay a fine and go to court, which he gladly did. Dick says that at the time, it wasn't funny and there is no excuse for hitting a woman, but it kind of tickles people's funny bones to hear the story now. The sweet old man with a soft voice sat before me and recalled the events that led up to that moment when he hit that mean ol' woman that day at the mill.

The woman worked in the same area as he did and was not very good at her job. She often shortened off her spools, which would make the thread run out too quickly. This would throw the whole

The Buck Creek Mill Jail. *Author's collection.*

production line off and cause a problem, so Dick would get on her and would have to help her clean up the mess. This happened time and time again. She got ugly with him one day, and he said, "I don't give a damn what you say." That woman acted like she had just been really badly cussed out and ran into the manager's office to complain in hopes of getting Dick fired. The boss called Dick into the office for his side of the story. The boss wanted to fire the woman immediately after learning about her poor work performance. Dick felt bad and talked his boss out of firing her, but his show of mercy in front of the woman did nothing to change how she felt toward Dick. She whispered to one of her girlfriends after leaving the manager's office that she would have Dick fired by the end of the day.

Upon returning to her station, she stewed and devised a plan. She intentionally busted a machine that caused yarn and other parts to go dangerously whirling around the room. It could have seriously injured or killed someone. She had hoped to send Dick into a fit of anger perhaps and get him fired that way. When the two started

arguing again, another boss stepped in to see what happened. Dick told the boss that she had broken the machine and could have killed someone. The woman called Dick a liar. This continued on for several minutes until finally the woman admitted to breaking the machine and then turned to Dick and said, "But you are still a liar." Dick's mother always told him growing up that there was nothing more lowdown than a thief and a liar because when a man loses his word, he loses everything. He had never told a single lie. He told the woman, "Call me a liar one more time, and I'll bust your teeth out!" The woman didn't hesitate to taunt him again, and neither did Dick to keep his word. Wham! He hit her hard in the mouth, and she hit the floor with her rather plump backside and bounced. They were both dismissed that day. Dick was allowed to come back, but the trouble-making woman was finally fired.

Work life inside the mill was hard. By all accounts, the managers were fair and good people. The work itself was difficult, though. The weaving room had to be kept humid at all times so the thread wouldn't break. Workers endured extremely hot conditions. Although I could find no reports of deaths, I did hear of several accidents that left workers without fingers. Lint was constantly floating about in the air and caused breathing difficulties for some. By the end of a shift, an employee would leave with white lint covering their hair and sometimes blue dye covering their fingers. There was no time to take lunch breaks during a shift either. The mill ran nonstop from the time it started on Monday morning until it stopped at the end of the week. Employees worked on Thanksgiving, Christmas Eve and New Year's Day. The only time they had off was weekends and one week every July.

Despite the difficult work, people liked working at the mill. Many of the past employees I spoke to worked there for decades until the mill closed and said they would still be working there if it had not. They were treated decently and given an affordable place to live. That is more than most jobs can offer today. Micheline Davis worked for the mill for twenty-four years as a weaver. She stood on her feet

all day and sometimes even took a double shift for extra money. She moved to the United States from France with her husband, who was a soldier, in 1948. After working over a decade at the mill and not having enough money to ever go back home to see her family, she started getting depressed. Her boss noticed the change in her mood, and he knew exactly what would make it better. One day when she came into work, she was called into the office. Management gave her a plane ticket to France and spending money. They gave her new clothes and paid for her to have her hair done. Her mother had died when she was only nine months old, so her father in France meant the world to her. She was overjoyed at their generosity. She will always remember their kindness and also how her father was waiting for her at the end of the road when she arrived home.

There were many more stories like Micheline's. The quiet little mill village was filled with people who had hearts of gold, and that is all that really matters. People looked after one another. No one needed to lock their doors because it was a safe place, which is why it is rather mysterious that the area surrounding Buck Creek and the

Is that the Buck Creek phantom peeking around this investigator's arm? *Author's collection.*

old mill site have earned the reputation of being haunted in recent years. Eyewitnesses have told of a phantom with red eyes lurking about in the woods behind the mill and in the old jail. Feelings of being watched and panic have overcome some of those who have ventured out there at night. One woman reported being tapped on the shoulder by an unseen person and hearing the voice of a woman near the bridge that crosses over Buck Creek.

It is hard to imagine any of the millworkers or residents of the mill village haunting the Buck Creek area, but there is an interesting part of Buck Creek's history that predates the mill. It was once used as mustering grounds for the Second Creek War in 1836. Perhaps the angry energy of the soldiers and Creek Indians alike has been recorded here. Perhaps there's an untold story of brutality that took place during that struggle that was swept under the rug like so many of those stories were during that war. We will never know the phantom's true identity, but I think we can put the rumors to rest that the good people who have worked and played at Buck Creek Mill over the decades have anything to do with the phantom's ruses.

BIBLIOGRAPHY

Books

Babcock, Barbara. *Woman Lawyer: The Trials of Clara Foltz*. Stanford, CA: Stanford University Press, 2011.

Ellisor, John T. *The Second Creek War: Interethnic Conflict and Collusion on a Collapsing Frontier*. Lincoln: University of Nebraska Press, 2010.

Hall, Pat, and Jane Newton Henry. *Images of America: Leeds, Alabama*. Charleston, SC: Arcadia Publishing, 2012.

The Heritage of Shelby County, Alabama. Clanton, AL: Heritage Publishing Consultants, Inc., n.d.

Nelson, Scott Reynolds. *Steel Drivin' Man: John Henry, the Untold Story of an American Legend*. New York: Oxford University Press, 2006.

Penhale, Ken, and Martin Everse. *Images of America: Helena, Alabama*. Charleston, SC: Arcadia Publishing, 1998.

Sims, Louise M. *The Last Chief of the Kewahatchie*. Raleigh, NC: Pentland Press, Inc., 1997.

Journal Articles

Roberts, Barbara. "Sisters of Mercy." *Alabama Heritage*, no. 11 (winter 1989): 2–17.

Unpublished Sources

Haveman, Christopher D. "The Removal of the Creek Indians from the Southeast, 1825–1838." PhD dissertation. Auburn University, 2009.

Nivens, Shelby S., et al. "The Legend of the May Plantation." Shelby County Historical Society, 2001.

Interviews

Baker, Pam, and Jerry Baker. July 1, 2013, Old Baker Farm.

Baker, Shawn. July 2, 2013, Harpersville.

Baldwin, Mildred. March 12, 2013, Buck Creek Mill.

Brooks, Thadeus. March 12, 2013, Buck Creek Mill.

Davis, Micheline. March 12, 2013, Buck Creek Mill.

Davis, Virginia. March 12, 2013, Buck Creek Mill.

Emfinger, Henry. February 16, 2013, Aldrich Mining Town.

Falkner, Buck. April 17, 2013, Falkner Family.

Foster, Danny. January 8, 2013, Shelby County Legends.

Green, Leslie. March 12, 2013, Buck Creek Mill.

Hall, Pat. June 26, 2013, Leeds.

Hamilton, Kathy. January 21, 2013, Magnolia Springs Manor.

Jones, Tracy. February 23, 2013, Chelsea.

Leonard, Mike. May 12, 2012, Old May Plantation.

Moore, Andrew, and Diane Moore. October 11, 2012, Densler House.

Perkins, Theo. October 20, 2012, Harpersville; February 20, 2013, Tot Chancellor.

Posey, Dick. March 12, 2013, Buck Creek Mill.

Serafin, Faith. June 29, 2013, Brierfield.

Stone, Chan. January 9, 2013, Chancellor House.

Websites

About.com Oldies Music. http://oldies.about.com.

Alabama Pioneers. http://alabamapioneers.com.

Alabama Trails, War of 1812. http://www.alabamatrailswar1812.com.

Birmingham Public Library Local Databases. http://bpldb.
bplonline.org.

Elvis Presley Music. http://www.elvispresleymusic.com.au.

Encyclopedia.com. http://www.encyclopedia.com.

Encyclopedia of Alabama. http://www.encyclopediaofalabama.org.

ExploreSouthernHistory.com. http://www.exploresouthernhistory.com.

Family Search. https://familysearch.org.

The Fighting Joe Wheeler Dispatch. http://www.fightingjoewheeler.org.

Friends of Caritas. http://friendsofcaritas.com.

IMDB. http://www.imdb.com.

Leeds Scenic Byway. http://www.leedsscenicbyway.com.

Medjugorje. http://www.medjugorje.ws.

Old Baker Farm. http://www.oldbakerfarm.com.

Rootsweb. http://www.rootsweb.ancestry.com.

Shelby County Reporter. http://www.shelbycountyreporter.com.

Waymarking.com. http://www.waymarking.com.

Wikipedia. http://en.wikipedia.org.

World History Project. http://worldhistoryproject.org.

ABOUT THE AUTHOR

When not leading her team of paranormal investigators into dark, spooky places throughout the Southeast, Kim Johnston can be found spending time with her family in her Chelsea, Alabama home. She is the mother of three children and the devoted wife to the love of her life, Dan. She graduated with honors from Auburn University at Montgomery and holds a degree in psychology. Kim works full time as a software developer in the insurance and healthcare industries. She is the

Courtesy Kathryn Hobson.

founder of Spirit Communications and Research (S.C.A.R.E.) and has been investigating paranormal phenomena since 2011 after events in her own home made her curious. Her team has investigated grand old places such as the Thomas Jefferson Hotel in downtown Birmingham and has even spent the night locked

inside the brick walls of Fort Morgan. Her team also does private home investigations and has helped many local families cope with hauntings. She can be contacted at kim@scareofal.com. For more information about her team, please visit www.scareofal.com.

Printed in the USA
CPSIA information can be obtained
at www.ICGtesting.com
LVHW060022091023
760463LV00014B/28